Food Photography

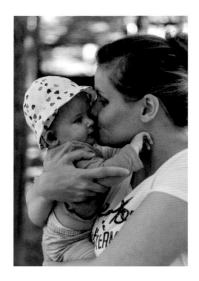

Corinna Gissemann comes from Berlin. In 2011, she decided more or less overnight to become a stock photographer. She taught herself all the basics and photography has since become her preferred form of creative expression.

Food and still life have always been Corinna's favorite genres, and her work can be found at various international agencies, in a broad range of publications, and on many people's walls.

To find out more, visit corinnagissemann.de or send Corinna an email at info@corinnagissemann.de

Corinna Gissemann

Food Photography

A Beginner's Guide to Creating Appetizing Images

rockynook

Food Photography
Corinna Gissemann
http://corinnagissemann.de/

Editor: Jocelyn Howell
Project manager: Lisa Brazieal
Marketing: Jessica Tiernan
Translation by: Jeremy Cloot
Layout and type: Cora Banek, www.corabanek.de
Cover design: Helmut Kraus, www.exclam.de

ISBN: 978-1-68198-101-7
1st Edition (1st printing, July 2016)
© 2016 Corinna Gissemann
All images © Corinna Gissemann unless otherwise noted

Rocky Nook Inc.
1010 B Street, Suite 350
San Rafael, CA 94901
USA

www.rockynook.com

Distributed in the U.S. by Ingram Publisher Services
Distributed in the UK and Europe by Publishers Group UK

Library of Congress Control Number: 2016930695

This book is printed on acid-free paper.
Printed in China.

This book is dedicated to my parents, who have always supported me in everything I do; to my wonderful husband, who never loses his patience, whatever I may be up to; and, of course, to my little bundle of sunshine, my daughter Emma, who is just as crazy as I am.

Table of Contents

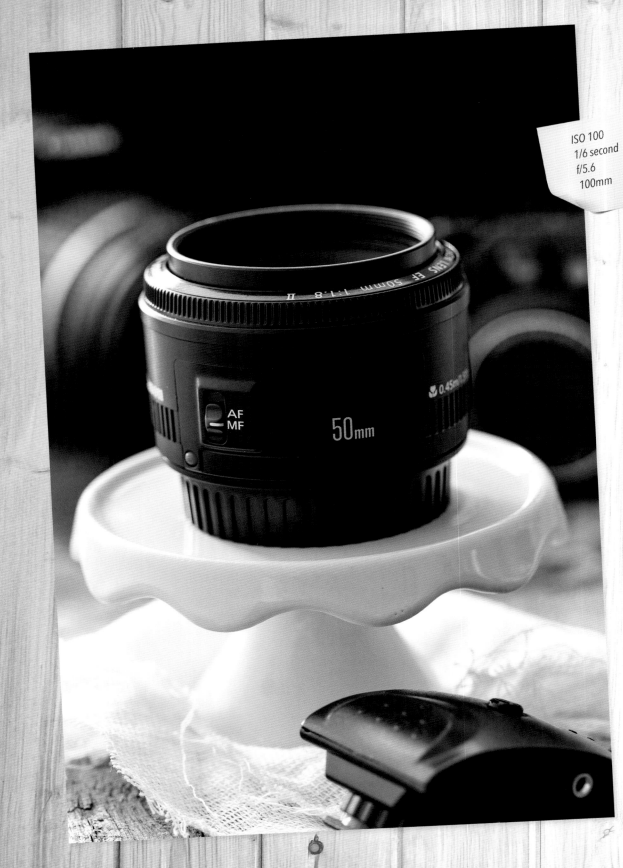

ISO 100
1/6 second
f/5.6
100mm

CHAPTER 1

What Gear Do You Need?

So what do you need to shoot great food photos? The most important thing is the food itself. If you don't have some kind of edible subject I guess you wouldn't be reading this book in the first place. Alongside the subject itself, the gear you use is an important factor, so we'll cover this topic in detail.

Consider this old joke: A cook says to a photographer, "Your photos are great—you must have a really good camera!" The photographer replies, "I love your food too—you must have great pots and pans."

Just as a good cook can create a wonderful meal regardless of the types of pots, pans, and knives she uses, you can capture great images of food using a cell phone, a full-frame DSLR, or whatever camera you like. Once you have made your initial investment in a camera and a lens or two, any additional gear shouldn't cost very much at all.

The gear you need depends on how you use the results. Using a cell phone to take pictures you plan to post on social networking sites requires a different approach than shooting high-quality images for your food blog or commercial sale. This book assumes that you are aiming higher than just using your phone.

When I am shooting food, I use a full-frame DSLR with 50mm, 100mm, and 70–200mm lenses, an accessory flash, a tripod, and various light shapers (more on these later). However, you can follow all the tips in the text using a compact camera, as long as your camera allows you to make some adjustments. Check your camera's manual to see what's possible and what's not. If you want to try food photography using your phone, check out the list of apps that simulate features found in "real" cameras at the end of this chapter.

So what exactly makes a food photo great? If you look at the work of established food photographers, you will notice that most of them contain some or all of the following elements:

- Deliberate use of sharpness and blur
- Lighting effects (the direction, style, and color of light, as well as contrast between light and dark)
- Color
- Textures (the style of the surfaces involved)
- Props such as plates, flatware, backgrounds, etc.
- A specific arrangement of the subject within the frame
- Careful use of perspective, angle of view, and camera viewpoint (usually close to the subject)

An interchangeable-lens reflex camera

A compact camera with a built-in lens

Only the first two points have anything to do with the gear you use, and you will learn all about the others in the course of this book. The following sections will help you decide what you need.

Which Camera?

There is no "right" camera for food photography, and you will probably want to use your camera to photograph other things too. The basic types of camera available are compact, reflex, and mirrorless system cameras. Without going into the number of megapixels a camera has—all of today's cameras have enough, unless you want to print images for house-sized posters—the differences between the various types are as follows: Compact and "bridge" cameras have built-in lenses, whereas the lenses in reflex and mirrorless system cameras can be swapped, allowing you to select the ideal lens for the job at hand. This is a great advantage in food photography, but it also tends to be more expensive. If you do decide to purchase a compact camera, make sure it has a fast lens with a maximum aperture of at least f/2 (I'll explain what this means in the next section) and a zoom range that covers everything from medium wide-angle to medium telephoto. A short minimum focus distance is really useful

too, as it reduces the distance between the camera and the subject, and food photographers usually like to get up close to their subject. You also need to be able to set the exposure time, the aperture, and the ISO sensitivity manually (see page 24). Food photography with a compact camera is only fun if all of these criteria are fulfilled. If you use a reflex or mirrorless system camera, these will all be standard features. Ask your photographer friends which camera they recommend. The next important matter to discuss is what to look out for when choosing a lens.

The minimum focus distance is the shortest distance between the camera and the subject at which the lens can still focus correctly

Which Lens?

The lens is probably more important than the camera itself, as it determines how the subject is captured by the camera's sensor. The two important factors here are the maximum aperture and the focal length. The larger the maximum aperture (i.e., the smaller the number), the more expensive the lens will be. A large aperture allows more light to reach the sensor, thus allowing you to use a shorter exposure time to correctly expose your image. For example, a lens with a maximum aperture of f/2.8 captures twice as much light as one with a maximum aperture of f/4. A wide aperture also produces a brighter viewfinder image, making it easier to compose your image. Perhaps most importantly, a wide aperture reduces the depth of field in your image and produces more blur in front of and behind the focal plane (see page 17). Points of light captured in these defocused zones appear as blurred circular dots known as bokeh, which are very popular in food photography circles.

The other important lens metric is its focal length. This determines the angle of view within which you can capture a subject. A 50mm lens is usually referred to as a "standard" or "normal" lens, as it has an angle of view that is virtually identical to that of the human eye and produces images with a very natural look. Focal lengths of less than 50mm are called "wide-angle." The shorter the focal length (i.e., the smaller the "mm" number), the wider the angle of view and the greater the amount of your subject you will be able to capture within the frame. Regardless of the aperture setting you use, wide-angle lenses produce images with greater depth of field but also distort shapes, especially at the edges of the frame. Wide-angle lenses are rarely used for food photography.

Lenses with focal lengths of more than 50mm are considered telephoto lenses, and the larger the "mm" value used to describe a lens, the narrower the angle of view and the greater the magnification. Telephoto lenses produce images with less depth of field, and produce a nice degree of blur in front of and behind the

The lamps in the background have been transformed into a chain of bright bokeh dots.

Left: A sample image captured with a 50mm lens.

ISO 100, 1.3 second, f/8, 50mm

Right: The same subject captured from the same position using a 100mm macro lens.

ISO 100, 1.2 second, f/8, 100mm

focal plane at medium apertures. They also visually compress the subject, making the foreground, subject, and background appear closer together than they really are. The images above show the results of capturing a subject from the same viewpoint using 50mm and 100mm fixed-focal-length lenses. Although the subject distance was the same, the angle of view and framing are completely different.

Remember: The smaller the aperture number, the brighter the lens; and the longer the focal length, the narrower the angle of view. Lenses with focal lengths of less than 50mm are called wide-angle and those with focal lengths above 50mm are called telephoto.

Lenses with variable focal lengths are called zooms and those with fixed focal lengths are called primes. Zooms offer more flexibility when it comes to selecting the angle of view, while prime lenses usually produce higher-quality images. Because they are easier to design and manufacture, primes are often cheaper too. A 50mm standard lens offers great image quality and a wide maximum aperture for an unbeatable price. Because I usually work in a controlled studio environment and my subjects don't move, I use 50mm and 100mm prime lenses almost exclusively. These cover most of my daily needs.

As mentioned previously in connection with compact cameras, make sure your lens has a short minimum focus distance. Some legacy lenses can only focus at distances of three feet or more and are therefore of no use for food photography.

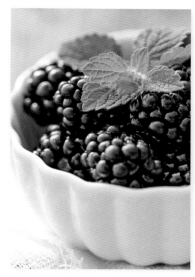

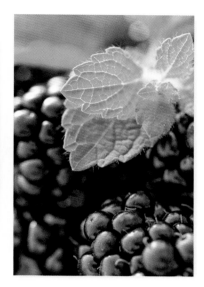

An overview captured with a macro lens.
ISO 100, 1.4 second, f/5.6, 100mm

A detail of the same subject captured with the same lens.
ISO 100, 1.4 second, f/5.6, 100mm

And a closeup, also captured with the same lens.
ISO 100, 0.8 second, f/5.6, 100mm

Macro Lenses

Macro lenses usually have a very short minimum focus distance, making them ideal for getting up close to food subjects or photographing selected details (see page 62). You can use a macro lens to fill the frame with a small portion of a subject at reproduction ratios all the way down to 1:1 or more, which means that the subject is reproduced at life size (or greater) on the sensor. When considering a purchase, note the maximum reproduction ratio a lens offers—the appropriate metric is usually printed or etched onto the surface of the lens body.

Macro lenses are available in a range of focal lengths. I use a 100mm Canon macro lens with a high magnification that enables me to shoot from farther away than I could using a 60mm lens. The shorter the lens, the closer you have to get and the greater the risk of actually touching the subject with the lens. Macro lenses also have extremely shallow depth of field. This creates shallow field of focus behind the subject and a slightly deeper field of focus in front of it. When using a macro lens, you have to take care focusing and setting the aperture if you want to avoid producing too much blur. Try taking some test shots with a small aperture of around f/11 to get a feel for the right setting.

While reading this book, you are sure to notice that I love my 100mm macro lens. If you want to know why, check out the photos above. I captured these blackberries from close up, then closer, then closer still. Even the tiniest details are still in sharp focus in the closeup shot on the right.

A tripod

A cable remote release

When purchasing a tripod, make sure the head you buy suits your camera. A quick-release plate saves a lot of time and hassle when you mount and unmount your camera.

Using a Tripod

If you use long exposure times, you need a tripod to keep your camera steady. A generally accepted rule of thumb states that you can only keep the camera steady handheld using an exposure time of 1/focal length—i.e., 1/50 second for a 50mm lens, 1/100 second for a 100mm lens, and so on. Camera shake becomes very obvious at the close subject distances involved in most food shots. Using a tripod also makes it easier to focus manually. Tripods are available in all manner of shapes and sizes—from pocket-sized for tabletop use to six-foot monsters designed for use with large, heavy cameras. There are various accessories available for attaching cell phones to a tripod. The head and legs of larger tripods are sold separately, and high-quality tripod heads are usually fitted with a quick-release plate that attaches to the camera.

Working with a tripod can be awkward if you are not used to it, but once you've had some practice, your tripod is sure to become a faithful companion on many of your shoots. It is easier to select your viewpoint and shooting angle (see page 61) handheld before you attach your camera to a tripod.

Remote Shutter Release

A remote shutter release helps to prevent unwanted camera shake when you are working with a tripod. Regardless of how careful you are, pressing the shutter button will manually jog the camera and produce tiny vibrations that can easily produce blur in the image you capture. Remote releases are available in wired and wireless versions. As an alternative, you can use your camera's self-timer, although you will probably find this approach too time-consuming. Tethered Capture (see chapter 7) enables you to release the shutter remotely via the Lightroom software interface and is a great alternative to using a remote release.

Artificial Sources of Light

Capturing photographs requires light. I prefer to use daylight if possible, but there are numerous other sources of light to choose from when there isn't sufficient ambient light. The best type of light to use depends on the circumstances. If, for example, you shoot mostly in the evening, a daylight lamp or flash is the best option.

Don't use normal room lighting or a table lamp, as these will cause unwanted color shifts. See chapter 3 for more details on lighting. If you do use artificial light, always use light shapers to soften the shadows produced by the light source. These include softboxes, diffusers, and shoot-through umbrellas, all of which are available for studio lights and flash. The effects that light shapers have on your photos are also described in chapter 3.

A studio flash fitted with a softbox

White Balance Using a Gray Card

You need to use a gray card to set white balance if you want to capture authentic-looking colors under tricky lighting conditions. You can do this either while you shoot (see your camera's manual for details on how) or later at the image processing stage. Once you have saved the tonal value of your gray card to your camera and/or software, you can adjust the colors in a photo taken under tricky lighting conditions with a click of your mouse. See chapter 2 (page 24) and chapter 7 (page 164) for more on how this works.

A studio flash fitted with a shoot-through umbrella

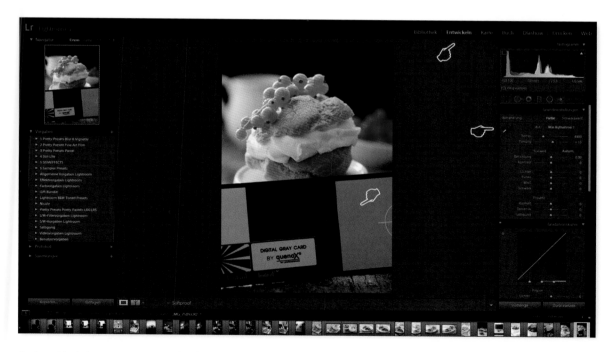

Setting white balance using a gray card and Lightroom.

Left: Incorrect white balance.
ISO 100, 1.6 second, f/5.6, 100mm

Right: Correct white balance achieved using a gray card.
ISO 100, 1.6 second, f/5.6, 100mm

A memory card

Memory Cards

You need a memory card to save the photos you shoot. If you capture a lot of photos using a RAW format (see page 23), you will need a high-capacity card to handle the large image files. Images of bright scenes usually require more disk space than dark images. Remember, though, that the larger your memory card, the greater the risk of losing a lot of work if it breaks. Spread the risk by using multiple medium-capacity cards. You don't need the super-fast cards used by video-makers, but be sure to purchase high-quality cards to minimize the risk of them failing.

A portable hard drive

Hard Drives

If you put a lot of work into your photos, you don't want to run the risk of losing them due to a hardware crash, so using a portable hard drive to back up your work is always a good idea (see page 184). The size of the drive you require depends on the amount of files you need to back up. If you want to back up your RAW and JPEG files, you will need much more disk space than if you save only your JPEG files.

Image-Processing Software

Once you have captured your photos, you are sure to want to view them on a computer monitor and process them. There is a huge range of image-processing programs on the market—some commercial, some free. I prefer Adobe Photoshop Lightroom, which is easy to use and offers plenty of flexible processing options. See chapter 7 for some hands-on Lightroom processing examples.

Cell Phones

If you want to try using your cell phone to shoot food photos, remember that its lens behaves like a wide-angle lens, with great depth of field that you can only use compositionally if you position the phone very close to your subject. The problem with this approach is that short subject distances produce obvious distortion. Additionally, phone cameras don't have adjustable apertures, so if you want to create blur effects they will have to be added later during post-processing. Just like when you shoot using any other type of camera, note the following when you use a phone camera for food photography:

- Use manual settings rather than auto mode whenever possible

- If possible, set the white balance manually before you shoot

- Never use your camera's built-in flash

- Increase the exposure time to compensate for a lack of ambient light

You will need one or more dedicated apps to make shooting and processing images with your phone a pleasant experience. The following are some of the better apps that I have used:

- Pro Camera (enables you to manually adjust ISO sensitivity and exposure time)

- Snapseed (popular, full-featured image-processing app)

- Tadaa SLR (enables post-shoot focus and depth-of-field adjustments)

- VSCO Cam (includes a range of filters that simulate analog film types)

This image was captured with a cell phone and processed with the Snapseed app.

I captured this image with a cell phone and added a "Lens Blur" effect...

...then I added an additional creative filter effect.

I captured the photo on the previous page with my phone and adjusted its sharpness and contrast using Snapseed, just as I would in Lightroom.

The app also has a filter called "Lens Blur" that I used to simulate shallow depth of field. Getting authentic-looking results with the filter isn't particularly easy, but practice makes perfect! You can see obvious foreground and background blur in my shot. You can regulate these effects as you wish using the app, and you can also select which parts of the image you wish to have in focus.

Most apps have some built-in, adjustable effects filters, and the photo above right shows the result of adding one of these to the original shot.

Remember, cell phone cameras have clear technical limits, and apps can only begin to simulate the sophisticated effects you can achieve with a high-quality compact or system camera.

Of course, it is much easier to share photos that you have captured with your phone, but the rest of this book assumes that you are more interested in the creative possibilities offered by "serious" cameras. The next chapter delves into the basics of photography using this type of gear.

#nofilter (well, almost)
If you use apps to process your food photos, don't apply too many filters because they can spoil rather than enhance the overall effect.

ISO 100
1.2 second
f/5.6
50mm

CHAPTER 2

Basics

Even though I am sure you want to get started right away, we need to take a look at some potentially boring theory before we really get going. After all, apertures, exposure times, ISO values, and white balance are just as important as styling and choosing the right props. If you don't take the time to learn how to expose a photo correctly, you will quickly get frustrated or even lose patience and give up photography altogether. If you have already begun taking food photos and are asking yourself why your shots turn out blurry, too dark, or with strange color casts, this chapter will provide you with the answers—promise!

Take the time to read the following sections carefully. Once you have, you will understand the various camera functions and the relationships among them, and you will have a much better idea of how your camera works.

Farewell, Auto-Hello, M Mode

Light is the all-important factor in photography; without it there would be no photography. This chapter is all about how to set the correct exposure parameters—in other words, how to ensure that the right amount of light enters the lens and reaches the sensor. The amount of light that enters the camera is determined by the interplay between the aperture and the exposure time, and is also influenced by the sensor's sensitivity (i.e., the ISO value), which is also variable. All digital cameras have an auto mode that enables you to press the shutter button without having to concentrate on your settings at all. In principle, this is really practical, but because it gives you no control over the aperture or exposure time, auto mode rarely produces genuinely satisfactory results.

Take time to get to know the other exposure modes your camera offers. Most cameras have the following modes built in:

- Av or A (Aperture Priority)
- Tv or S (Shutter Priority)
- P (Program AE)
- M (Manual)

In Av *(Aperture Value)* or A mode, you set the ISO value and the aperture, and the camera automatically selects an appropriate exposure time. This can be a problem if you are working handheld and the selected exposure time is long enough to produce camera shake.

In Tv *(Time Value)* or S mode, you set the ISO value and the exposure time, and the camera automatically selects an appropriate aperture. The obvious drawback to this mode is that you have no control over the depth of field in the resulting image.

In P mode, you can only alter the ISO value; the camera selects all the other settings automatically. Here too, you have no influence over depth of field or potential camera shake.

If you have only ever used these modes, your camera has been adjusting some or all of the settings for you. However, you will be more independent and your shooting style will become more flexible if you adjust these settings yourself, which means working in M mode. In M mode, you can adjust all three basic shooting parameters as you wish. Careful selection of the aperture and exposure time not only enables you to create correctly exposed photos, but it also gives you complete creative control over the look of your images.

But how do you make sure that you achieve a correct exposure if you set the aperture, exposure time, and ISO value yourself? Imagine the three parameters as the three sides of a triangle with the correct exposure in the center. This notion depicts the relationships among the three factors and is known as the exposure triangle.

The following sections look at each of the three factors. Once you have read these sections, I promise that setting up a correct exposure will no longer seem so daunting. You will also understand the aperture, exposure time, and ISO values printed with each sample photo in this book.

The "exposure triangle" shows the interplay between the aperture, exposure time, and ISO settings, and illustrates how to use them to set exposure correctly.

long (e.g., 4 seconds)

low (e.g., ISO 100)

decreases/increases motion blur

EXPOSURE TIME

ISO VALUE

reduces/increases image noise

CORRECTLY EXPOSED PHOTO

short (e.g., 1/1000 second)

APERTURE

high (e.g., ISO 6400)

wide open (e.g., f/2.8)

decreases/increases depth of field

stopped down (e.g., f/22)

Setting the Aperture

A camera's aperture is made up of multiple blades that open and close to vary the amount of light entering the lens. Aperture values are given in terms of the ratio of the focal length of the lens to the effective diameter of the aperture—for example, f/2.8 or f/11. The wider the aperture (i.e., the smaller the f-number), the greater the amount of light entering the lens. Conversely, the larger the number, the smaller the aperture and the less light it allows through. Shooting with a wide aperture (i.e., a small f-number) reduces the depth of the area in front of and behind the subject that will be in sharp focus in the resulting image—the rest disappears into a pleasant, hazy blur. In contrast, if you shoot using a high f-number (f/16, for example), the depth of field will increase.

The aperture you use (and the depth of field it provides) is a crucial factor in the design of food photos. Deliberate use of blur enables you to steer your viewer's gaze toward the most important part of the subject, thus emphasizing specific elements such as the herbs decorating a soup or the texture of a delicious dessert.

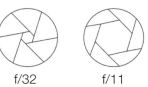

f/32 f/11 f/2.8

Small, medium, and wide apertures

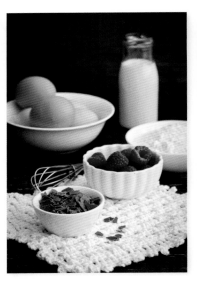

With the aperture stopped down small, just about everything is reproduced in sharp focus.
ISO 100, 10 seconds, f/32, 100mm

The wider the aperture, the more blurred the background becomes.
ISO 100, 1 second, f/11, 100mm

Using the maximum aperture allows you to direct the viewer's attention to precisely the right spot.
ISO 100, 1/15 second, f/2.8, 100mm

The extent of the area in front of and behind the point of focus that remains sharp is called the <u>depth of field</u>, and it is key to the look of your images. A higher f-number (such as f/16) increases the depth of field, while a lower f-number (f/2.8, for example) decreases it. Depth of field increases with decreasing <u>focal length</u>, and also when you use a camera with a <u>smaller (i.e., non-full-frame) sensor</u>. The closer you are to your subject, the shallower the depth of field. Each of these factors affects depth of field independently of the others.

Take a look at the varying depth of field in these three images and note the impression produced by each. The photos were shot with the aperture closed down, half open, and wide open, and I focused on the dish of chocolate flakes in all three.

In the right-hand image, the depth of field is so shallow that only the dish is in focus, thus separating it from the rest of the objects in the frame.

Setting the Exposure Time

The next side of the exposure triangle represents the exposure time, which determines how long the shutter is open and therefore the amount of light that reaches the sensor during the exposure. Exposure times are expressed in fractions of a second, so an exposure time of 1/125 second is shorter than an exposure time of 1/60 second. A short exposure time allows you to "freeze" movements—such as powdered sugar being dusted onto a cake or dressing being poured over a salad—without the subject becoming blurred.

Poor light usually means you need to use a longer exposure time. If you cannot (or don't want to) open the aperture any further, you will often end up with some blur in your images due to camera shake. Depending on how steady your hand is and how much you practice, there are limits to the exposure times you can use without producing camera shake. A generally accepted rule of thumb states that the exposure time should be 1/focal length or shorter—in other words, if you are shooting with a 50mm lens, use an exposure time of 1/50 second or less. With a 50mm lens, an exposure time of 1/30 second is sure to produce blurred results.

You won't always be able to use short exposure times, so a tripod is essential in many situations. I don't think I'm exaggerating when I say that all food photographers use a tripod most of the time. Using a tripod can be tricky at first but the more you practice, the easier it will become. The subject is nearly always stationary in food photos, so a tripod is a really useful accessory to have.

Careful selection of the <u>exposure time</u> enables you to "freeze" movements and prevent camera shake. The accepted rule of thumb for shake-free photos is to use an exposure time of 1/focal length or shorter—for example, 1/50 second for a 50mm lens. This is the recommended limit and shorter exposure times ensure shake-free results when you are shooting handheld.

Left: A short exposure time freezes the movement of the falling sugar.
ISO 800, 1/400 second, f/5.6, 100mm

Right: A longer exposure time blurs the movement.
ISO 100, 1.5 second, f/5.6, 100mm

The exposure indicator in a camera's viewfinder

Once you have determined the basic look of your image with the aperture (and you should only alter the ISO value in an emergency), the exposure time is the parameter that determines how bright or dark your photo will be. Beginners often end up wondering why their photos turn out under- or overexposed.

Most cameras have a display that shows the exposure determined by the camera's built-in metering system. This usually looks like the one in the illustration above, with three units on either side of the center marking. The center point on the scale indicates technically correct exposure, and the points to the left and right indicate degrees of under- or overexposure, respectively. In a correctly exposed image like the center image below, the indicator will point to the center of the scale. In M mode, altering the exposure time causes the indicator to move to the left or right, depending on whether you reduce or increase the exposure time.

However, there is no such thing as "right" or "wrong" exposure, and varying exposure parameters can always be used as a tool to create a specific effect. For example, you can deliberately overexpose your image to create a bright, friendly, springtime effect. If you take this approach, be careful not to overexpose to a degree that causes burned-out highlights—these are pure, bright white areas that show no discernible detail. You can also deliberately underexpose your photo, especially if you are working on a darker, more rustic-looking shot. Here too, take care not to overdo the effect; otherwise, you will end up with "swamped" shadow areas with no detail. Always shoot in RAW rather than JPEG format if you can—this makes recovering any lost details much easier during post-processing. RAW image files are much simpler to darken or brighten in

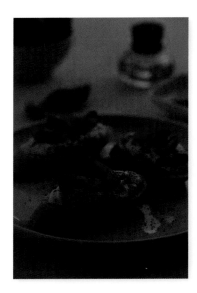

Underexposed
ISO 100, 1/160 second, f/5.6, 100mm

Correctly exposed
ISO 100, 1/40 second, f/5.6, 100mm

Overexposed
ISO 100, 1.6 second, f/5.6, 100mm

Lightroom (see page 162). Most cameras have a built-in warning feature that highlights potentially under- or overexposed areas on the monitor. Check your camera's manual if you are not sure whether your camera has this feature.

With a little practice, you will learn to recognize instinctively when a shot is likely to turn out poorly exposed. If you still need help getting exposure right, tethered shooting is a great technique for ensuring that your shots turn out as you imagine them (see page 154).

ISO Sensitivity

The final element in the exposure triangle is the ISO value, which denotes the light sensitivity of your camera's sensor the same way it denotes the light sensitivity of analog film. With film cameras, you have to decide in advance which film sensitivity you want to use and adjust the other shooting parameters to suit the ambient lighting conditions. Digital cameras are much more flexible and enable you to adjust the sensitivity value for each shot. The ISO range in most digital cameras begins at 100 or 200 (or 25 in some rare cases). If there is plenty of ambient light, you can usually shoot comfortably at ISO 100. However, if the light changes due to clouds or the onset of evening, you will usually have to increase the ISO value to get a good exposure. The downside of increasing the ISO value is that it produces more noise artifacts in the resulting images, usually creating areas of poor detail definition within the frame. These are easy to see if you view your images at 100 percent magnification on your monitor, but they aren't usually visible at the smaller magnifications used for publishing images on the web. Unwanted image noise is obvious in large prints too,

Captured at ISO 100, this shot contains virtually no visible noise.
ISO 100, 1/3 second, f/4.5, 100mm

This detail of a shot captured at ISO 2000 shows obvious noise.
ISO 2000, 1/60 second, f/4.5, 100mm

The noise in this shot captured at ISO 6400 spoils the effect of the image.
ISO 6400, 1/250 second, f/4.5, 100mm

although it can often be reduced digitally at the image-processing stage. The problem with this approach is that it usually reduces image quality as well.

Image noise varies with the size of the image sensor. The larger the sensor, the higher the ISO values you can use without running the risk of noise spoiling your images. Always shoot at ISO values between 100 and 400 if you can, and only increase the ISO value if you really have to.

The three images on the previous page illustrate the noise effects produced by increasing the ISO value. The higher the ISO value, the shorter the exposure time necessary to allow the correct amount of light to reach the sensor.

Putting It All Together

The aperture determines depth of field, the exposure time determines the degree of sharpness or blur, and the ISO value determines the sensitivity of the sensor. The ISO can be adjusted if you cannot or don't want to adjust either of the other two parameters. The downside of increasing the ISO value is that it increases the risk of image noise. Always shoot in manual (M) mode if possible. Two things make this easier than you may think. The first is the camera's built-in exposure indicator, which you can follow or ignore as you wish, and the second is the secret of how the exposure triangle works: If you adjust a parameter on one side of the triangle (for example, opening up the aperture from f/4 to f/2.8), you have to make a corresponding adjustment on one of the other two sides (e.g., reducing the exposure time from 1/125 to 1/250 second or, if possible, reducing the ISO value). The thing to remember is to correct only one of the remaining two parameters, and always by the same number of steps you used to adjust the initial parameter. Cameras are constructed so that one aperture step has the same effect as one step on the exposure time and ISO scales. To understand this concept, consider the following sets of parameters, which all produce the same overall exposure:

- 1/60 second, f/4, ISO 200
- 1/125 second, f/2.8, ISO 200
- 1/500 second, f/2.8, ISO 800
- 1/125 second, f/5.6, ISO 800

Using a wide-open aperture (f/2.8) allows more light to enter the lens but produces shallower depth of field in the resulting image. A stopped-down aperture (f/22) allows less light to enter the lens but produces much greater depth of field.

A long exposure time (1/20 second) allows more light to reach the sensor but increases the risk of camera shake. A short exposure time (1/1000 second) allows less light to reach the sensor but freezes movements and enables you to shoot shake-free photos hand-held.

A low ISO value (ISO 200) produces less noise, while a high value (ISO 3200) produces much more noise. Always use your camera's lowest available ISO value if you can. The lower the ISO value, the less noise your images will contain and the higher the overall quality of your images will be.

In practice, this means that you manually set the exposure determined by your camera's built-in exposure meter and then adjust the values on each side of the exposure triangle to achieve the effect you are looking for. Don't be afraid to experiment—there are no taboos, and achieving results that you like are what really counts!

RAW vs. JPEG

Ideally, your camera will allow you to choose between RAW and JPEG file formats. A RAW image file contains all of the data captured by the sensor in an uncompressed format. A JPEG file is compressed and preprocessed to include all of the camera settings you used when you took the picture (white balance, saturation, sharpness, contrast, and so on). You can post-process both file types, but adjusting JPEGs is more limited and always results in a loss of image quality. It is also virtually impossible to effectively adjust fundamental camera settings—such as white balance or incorrect exposure—in JPEG images. A JPEG image is a complete, processed package that is not designed for further adjustment. If you capture your images in JPEG format, you have to be pretty sure that all of your settings are correct when you shoot, which isn't always easy, especially for less experienced photographers. If you do decide to shoot in JPEG format, always use the highest available quality or resolution setting.

Shooting in **RAW format** uses up more space on your memory card and hard drive, and requires the use of specialized viewing and processing software. On the upside, RAW formats enable lossless processing.

JPEG formats compress image data and use less space on your memory card and hard drive. JPEG image files can be viewed using a huge variety of programs, but processing them always reduces image quality.

I recommend that you always shoot RAW, if possible. This way, you maximize your chances of getting the very best out of every image you make, and you can adjust white balance, sharpness, brightness, saturation, and contrast at the processing stage. This guarantees that you end up with high-quality images, which I assume is what you are aiming for.

White Balance

Now that you know all about the exposure triangle, your camera's auto exposure modes, and the difference between RAW and JPEG file formats, all that remains is to take a look at *white balance* (often abbreviated to WB).

Have you ever noticed how photos of the same subject have different colors in different types of light? To get an image looking right, you have to set the white balance to match the type of light illuminating the subject. This adjusts the color temperature of the image to give it an authentic, natural look.

Every light source has its own color temperature, measured in units called kelvin, or just K. The brightness and temperature of daylight changes throughout the course of the day. Daylight under a clear blue sky has a color temperature of around 5500 K, whereas a cloudy sky measures around 7600 K. Lower color temperature values indicate a greater red component and higher values indicate more blue.

The human brain is capable of differentiating between varying color temperatures perceived by the eye. A sheet of white paper always appears white regardless of whether it is lit by a table lamp or a flashlight. White balance takes place in your brain, which knows the color of paper and automatically compensates for the color of the ambient light.

In contrast, your camera doesn't know that paper is white and can only capture the real color temperature of the light entering the lens. This means that a sheet of white paper will have a red cast if you photograph it at sunset, a blue cast if you photograph it in a shadowy area, and a yellow cast if you photograph it in candlelight. If you don't adjust the white balance accordingly while you shoot or during post-processing, your photos will probably turn out less appetizing than you had hoped. There are three basic ways to make sure you get the white balance right:

- Use your camera's auto white balance setting. This is most reliable in daylight but can produce off-kilter results in tricky situations, such as when the sun is low in the sky or in artificial light.

- Set white balance manually. Most cameras have dedicated settings for daylight, cloudy sky, shade, and fluorescent light.

- Use a gray card to take a white balance reading for the scene at hand. You have to photograph your gray card under the same lighting conditions as the rest of your images for a particular session, and then use it as a reference during processing (see page 166) or to set the white balance in the camera. (See your camera's manual for instructions on how to do this.) If you take this route, you need to set the white balance separately for each new situation.

These four photos were all shot in warm, late-afternoon light, but with varying white balance settings.

If this all sounds too complicated, simply use your camera's Auto WB setting or its built-in settings for sun, cloud, shade, or artificial light.

Left: Using auto white balance usually produces the best results.
ISO 100, 1/20 second, f/5.6, 100mm

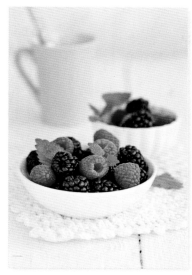

Right: For this shot, I set the white balance to "Daylight," which resulted in an obvious yellowy cast.
ISO 100, 1/20 second, f/5.6, 100mm

Left: When I set the white balance to "Incandescent," it gave the image a blue cast.
ISO 100, 1/20 second, f/5.6, 100mm

Right: Here I used the "Flash" setting, which produced very strange colors.
ISO 100, 1/20 second, f/5.6, 100mm

ISO 100
1.2 second
f/5.6
100mm

CHAPTER 3

Lighting

This chapter addresses probably the most important aspect of food photography: light. Light creates a mood and gives your food photos depth. Depending on the type of lighting you use, you can produce shots that are bright and lively or dark and mysterious. Light can be also shaped to suit your taste—do you like hard-edged shadows or do you prefer softer effects? Do you like light that comes from the side or do you prefer backlight? Lighting influences every aspect of a photo, from the subject itself to the background and other surroundings.

Have you already tried shooting with flash? Were you happy with the results or were you disappointed? This chapter aims to provide answers to some of the questions you may have. If I can, I always prefer to shoot my food photos in daylight, which gives my subjects a very special glow. I rarely use flash, but I will go into some detail on how to use it in emergencies. This doesn't mean you shouldn't use flash. Every photographer has his or her own personal preferences. If your lifestyle doesn't allow you to shoot during the day, flash may be the only answer. However you work, this chapter will help you find the "right" light.

Main and Fill Light

Before you decide which type(s) of light to use, you need to know the difference between main and fill light.

Because authenticity is essential in food photos, it is usually a good idea to use just one main light. This can be the sun or any artificial light source. Whichever you decide to use, switch off all other lights and set up your camera's white balance to match your main light. For example, if your favorite place to shoot is inside near a window, switch off the room lights when setting the white balance. If you don't, the mixed light sources will confuse the white balance system and produce skewed results. (We have already seen the results of using the wrong white balance setting in chapter 2.)

The main light determines the amount of contrast, the type of shadow, and the overall atmosphere in a shot. It also emphasizes or reduces the effect of the shape and texture of your subject.

A main light is usually supplemented by a fill light, which is used to optimize the lighting in a shot. A fill light usually reduces contrast and brightens shadows. A subsidiary light can also be used to emphasize specific subject areas or details within the frame.

In its simplest form, fill light is produced by using a reflector to redirect some of the rays from the main light. Complex setups use separate, slightly dimmer lamps to produce fill effects.

Daylight

Daylight is by far my favorite kind of light. It is there every day for free and is easy to work with. The "golden hours" just after dawn and just before sunset provide the very best daylight for taking photos, and produce low contrast with wonderful soft shadows. The challenge here is setting up your schedule so you can shoot at just these times.

A small window provides enough light to make great food photos, but the smaller it is, the more likely it is that you will need to use longer exposure times and/or a tripod.

A window works best if the ambient light doesn't shine directly through it. In the northern hemisphere, a north-facing window is best. Using this kind of indirect, diffuse light, you can shoot all day and produce photos that require little or no post-processing. If the sun shines directly through your window, you will have to be careful to choose the right time of day and the right weather for a shoot. A diffuser helps to soften direct sunlight (more on this later in the chapter).

Never underestimate the flexibility of daylight. Depending on the weather (sunny or cloudy), the time of day (cool or warm colors), and the direction of the light (from the side or from behind), daylight offers plenty of opportunities for creating new and exciting effects.

You don't have to set up your shot right by a window. Give yourself room to walk around your table and try out different shooting angles (see page 59). The only issue here is that as you move farther away from the light source, you will have to increase the exposure time (see page 19). However, this is a non-issue if you use a tripod.

The image on this page shows apricots with thyme. As you can see in the image of my setup, I used neither reflectors nor diffusers. Pure daylight can be used to produce wonderful food photos as long as you are happy with strong shadows and plenty of contrast.

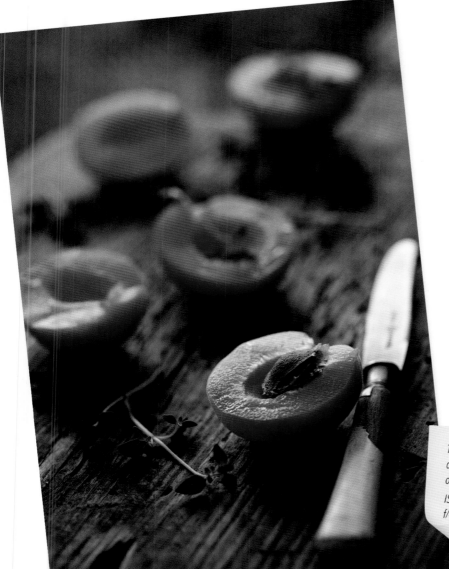

This is the setup I used to produce the shot of the apricots shown on the left.

This photo was shot in daylight without the use of a diffuser or reflector. ISO 100, 1/20 second, f/4.5, 100mm

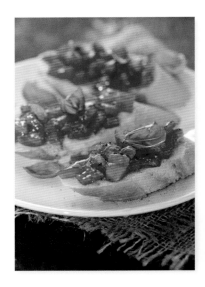 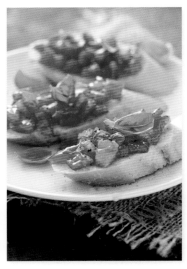

Left: In this shot, I lit my bruschetta with direct frontal flash. This produced a flat-looking result with obvious shadows behind the subject.
ISO 100, 1/6 second, f/5.6, 100mm

Right: For this version, I used M mode and no flash.
ISO 100, 1/3 second, f/5.6, 100mm

Artificial Light

If you simply don't have time to shoot during the day or the winter days are too short, there are plenty of artificial light sources available to help you shoot well into the night.

You can use either flash—and no, I don't mean the flash built into your camera, which you need to forget immediately!—or continuous light. This might sound complex, but continuous light in particular is quite easy to master.

The light source you use will depend on your personal preferences and your level of skill. Remember that artificial light can be made to look just like daylight and has the added advantage that you can adjust it precisely, regardless of the weather or time of day. Additionally, once it is set up, its quality, direction, brightness, and color remain the same until you decide to change things yourself.

The following sections go into detail on both flash and continuous lighting techniques and demonstrate how to use reflectors, flags, and diffusers to shape light as you wish.

Flash

Flash is a really useful and highly flexible source of light.

- Flash always produces the same quality of light, regardless of the time of day
- You can use flash to shoot handheld (i.e., without using a tripod)
- It is easier to freeze movements when you use a flash than it is in daylight or continuous artificial light
- Flash produces neutral white light with a color temperature similar to daylight

If you're thinking, "Great, my camera has a built-in flash," think again. Built-in flash illuminates the subject frontally, which usually produces unappetizing food photos. If you don't believe me, check out the two images on the previous page. Because I used the camera's built-in flash to capture the left-hand shot, the image looks "flat" and uninteresting. The right-hand shot was captured in M mode with the camera mounted on a tripod. In this image, the shadows are much softer and the shape and texture of the food itself is much clearer. Which photo makes the food look tastier?

If you have to use your camera's built-in flash, try to soften its effect as much as possible by covering it with a tissue, baking paper, or some kind of translucent fabric, such as a bed sheet. The following sections introduce the most important types of artificial light and explain how to use reflectors, flags, and diffusers to customize their effects.

On-Camera Flash

On-camera accessory flash is better than built-in flash, and you can also use it off-camera with the help of a cable or wireless trigger. If you already own an accessory flash but don't know how to use it, or if you have already experimented with flash but are not satisfied with the results, read on. The most important thing to remember when using on- or off-camera flash is to avoid pointing it directly at the subject. As we have already seen, this produces stark shadows and makes food look dull and unappetizing. So how do we go about changing things? The first thing to try is altering the position of the flash unit—for example, from full-on frontal to lateral from behind. As you can see in the example on the next page, this type of lighting setup creates a dramatic, high-contrast effect.

Only use your camera's built-in flash in emergencies.

Left: The flash is set up in front of the subject and illuminates it directly.

Right: The waffles and jam don't look very appetizing in the lighting produced by this setup.
ISO 100, 1/4 second, f/6.3, 100mm

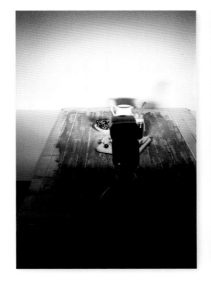

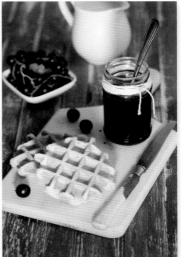

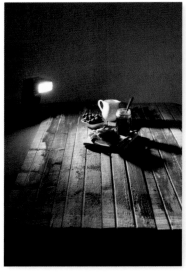

Left: Here the flash is set up laterally behind the subject and produces obvious shadows that are quite harsh.

Right: The result is an image that is much too dark on the right-hand side.
ISO 100, 1/4 second, f/5.6, 100mm

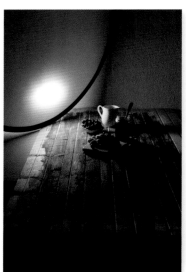

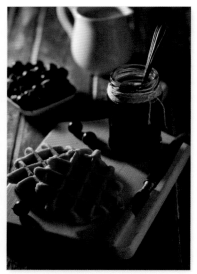

Left: I placed a diffuser in front of the flash to soften the shadows and enlarge the light source.

Right: The softer shadows make the overall effect more balanced.
ISO 100, 1/4 second, f/5.6, 100mm

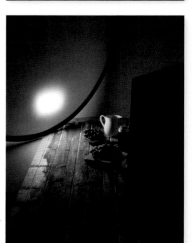

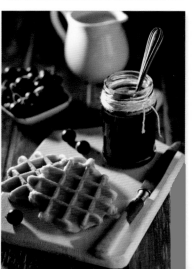

Left: For the next shot, I used an additional Styrofoam fill reflector on the right.

Right: The foreground is now much brighter.
ISO 100, 2 second, f/5.6, 100mm

One way to soften the light is to place a diffuser in front of your flash. This makes the light more diffuse and softens the shadows it produces. Can you see the difference? We will go into more detail on diffusers later in this chapter.

To lighten dark foreground details, you can place a reflector opposite your flash. As you can see in the final image of the waffles, this reduces the depth of the shadows and gives the photo a lighter overall look.

The light coming from the left creates a kind of "morning sunlight" look in the final processed image.

Using off-camera flash enables you to create numerous effects by simply altering the position or angle of the flash. Try it yourself!

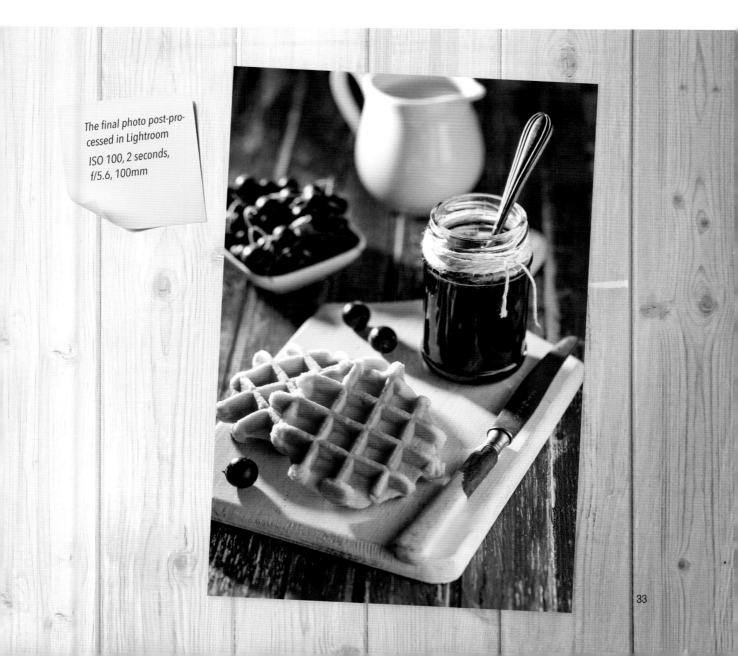

The final photo post-processed in Lightroom
ISO 100, 2 seconds, f/5.6, 100mm

Studio Flash

A studio flash rig is larger and more expensive than an accessory flash, but it provides much more light. There is a wide range of starter sets that include light shapers available on the web. The following example uses a simple studio flash setup to transform a poor snapshot into a delicious-looking food photo.

I used a dummy subject and a studio flash set up behind it for this ice cream shoot. The direct, full-power light from the flash produced dark shadows and too much contrast in my initial test shot. "Hard light" can be used as an effective compositional tool, but this shot required softer, more balanced lighting.

The first step in softening studio flash and the shadows it produces is to use either a softbox or an umbrella diffuser. A softbox produces more concentrated light, while a diffuser scatters the light. I used two additional flags to darken the left-hand side of my setup. Can you see the difference between the "before" and "after" versions?

Although it wasn't strictly necessary, I also decided to use a diffuser in front of the flash, which softened the brightness gradient from top to bottom and gave the image a more balanced feel. The best way to learn about lighting is simply to experiment with the available tools.

> Both remotely triggered and studio flash units are known as "off-camera" flash because they are positioned away from the camera.

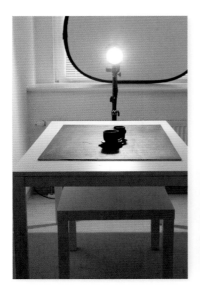

Left: I positioned a studio flash without a softbox directly behind the dummy to create backlight.

Right: The first test photo shows harsh shadows in front of the dummy.
ISO 100, 1/5 second, f/5.6, 100mm

Left: Here you can see the softbox I used on the flash and the two dark flags to the left of the subject.

Right: The shadows are much softer and the overall effect is more balanced.
ISO 100, 1/5 second, f/5.6, 100mm

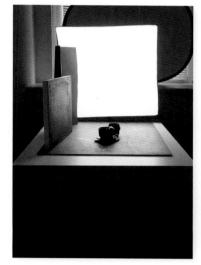

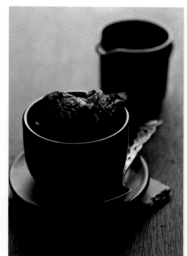

Left: I added a diffuser in front of the softbox.

Right: The diffuser made the background slightly darker and evens out the overall effect.
ISO 100, 1/5 second, f/5.6, 100mm

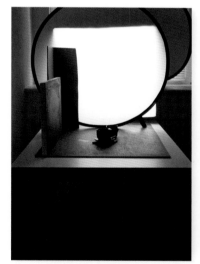

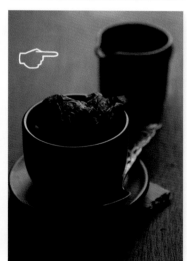

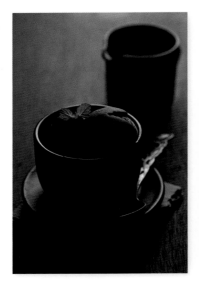

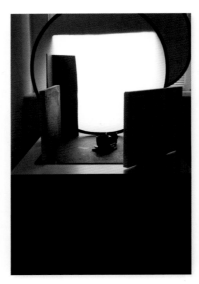

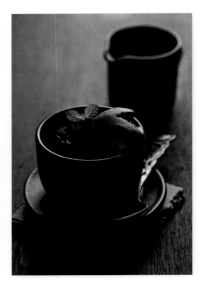

I replaced the dummy with real frosted ice cream. At this stage, the foreground is still too dark.

ISO 100, 1/5 second, f/5.6, 100mm

An additional fill reflector at front right lightens the front of the bowl.

The result, showing the effect of the fill reflector.

ISO 100, 1/5 second, f/5.6, 100mm

Always take your camera's **flash sync speed** into account. This is usually between 1/60 and 1/250 second and denotes the shortest exposure time at which the shutter is fully open while the flash fires. If you use a shorter exposure time, the shutter won't be fully open while the flash fires and you will see black stripes in your image as a result.

Once I was happy with the lighting it was time to remove the dummy and use real chocolate ice cream. My test shot was OK, but the front of the bowl was still a little too dark.

The only thing that was missing was an additional fill reflector to brighten the parts of the subject that were not lit directly by the main flash. I placed a reflector at front right and the difference was immediately obvious.

Post-processing is always a highly personal matter, and my final result was achieved using a Lightroom preset (see page 174). Now it's time for you to grab your flash and start experimenting.

Did you notice the mess I made with the frosting? Don't worry about this kind of thing; it is all part of the fun of making food photos. To make your own artificial ice cream, simply mix powdered sugar with margarine, add food coloring, and cool it in the fridge.

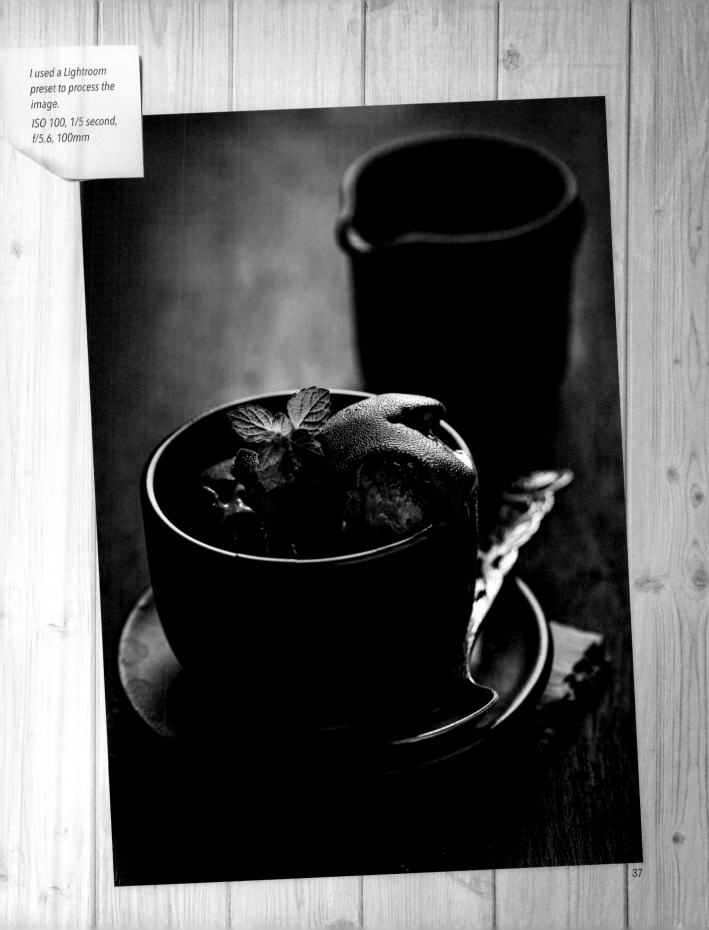

I used a Lightroom preset to process the image.
ISO 100, 1/5 second, f/5.6, 100mm

 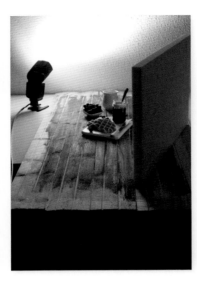 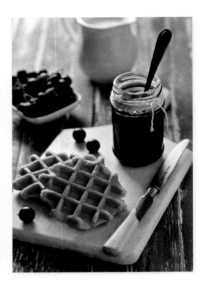

The frontal light produced by direct flash gives food subjects an unappetizing, flat look.

Here the flash is bounced off of a white wall.

The bounced flash softens the shadows, producing a much more balanced photo. ISO 100, 2 seconds, f/5.6, 100mm

Bounce Flash

As we have already seen, direct frontal flash is the kiss of death for many food photos, regardless of whether you use your camera's built-in flash or a more expensive accessory unit. You need to change something if you want your food photos to look delicious enough to get people cooking.

If you don't have a diffuser handy, one of the most effective ways to counteract dull flash effects is to bounce the light off of a wall, the ceiling, or a reflector. Reflected light is more diffuse and produces a much softer effect.

Continuous Light

Continuous artificial light is similar to daylight but its intensity and color temperature don't change while you shoot. It is also relatively cheap and easy to use, and with a little practice, it's sure to become a regular part of your food photography toolkit. The main advantage of continuous light over flash is that you can immediately see the effect of your lights while you are setting them up, so you can make adjustments right away without having to take test shots first. Daylight lamps can be quite expensive, are not always very bright, and get very warm. Applying heat is a sure-fire way to dry out your subject, so you need to plan your shoot carefully and use dummy props whenever possible.

Continuous light often needs to be softened too, and a softbox is a great tool for producing this type of effect. Softboxes are available online in many shapes and sizes. My softbox is quite small, measuring just 22 inches across, but is still large enough for most food jobs. The following example uses continuous light in a softbox set up behind and to the left of the subject. Note that daylight lamps need to warm up before they reach their specified intensity and color temperature. In the first shot (reproduced on the left), I used the exposure time the camera computed to suit the aperture of f/5.6. The result is okay, but it's a little too dark for my taste, so I doubled the exposure time to 1 second to get the result I was looking for.

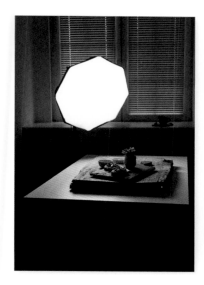 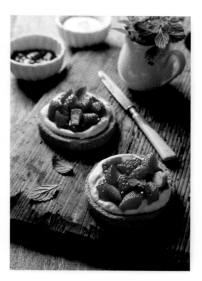 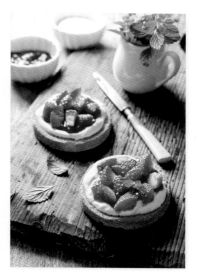

I placed a daylight lamp fitted with a softbox at back left.

The ½-second exposure time is too short and the photo turns out too dark.
ISO 100, 1/2 second, f/5.6, 100 mm

Doubling the exposure time to 1 second produces the desired effect.
ISO 100, 1 second, f/5.6, 100 mm

I have often heard about people using construction site lamps as photo lights, but these simply get too hot for effective use in food photography. Too much heat ruins food, especially if you are shooting in a relatively confined indoor space.

I then set up a Styrofoam reflector opposite the main light to brighten the details at front right and soften the shadows. If you want to further soften and scatter your light, you can add a diffuser to the softbox. If you do, the shadows will become virtually unnoticeable. I used this approach to get the right result.

Like with flash, continuous light is great for experimenting. The number of lights you use is up to you. If you have to decide whether to acquire continuous lights or flash, I definitely recommend the continuous option.

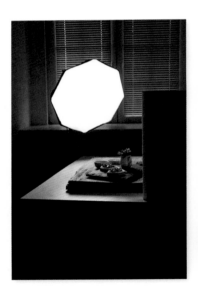

Here I used a sheet of Styrofoam at front right to lighten the foreground.

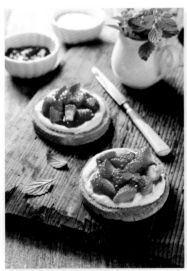

The Styrofoam reflector lightened the foreground shadows.
ISO 100, 0.8 second, f/5.6, 100mm

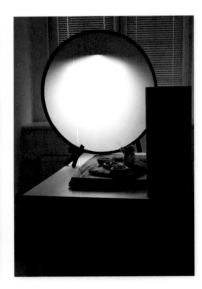

I used a diffuser in front of the softbox to further soften the main light.

The diffuser placed in front of
the softbox gives the light in the
finished image a really soft touch.
ISO 100, 1/3 second, f/5.6,
100mm

Reflectors, Flags, and Other Light Shapers

Reflectors and flags are tools used to strengthen, weaken, steer, and otherwise shape the light used to illuminate a photographic subject. The following sections explain how.

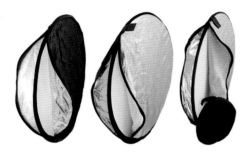

A collapsible reflector with white, silver, and gold surfaces, as well as flag and diffuser functionality

Reflectors and Fill Effects

As we have seen in the previous examples, the main purpose of a reflector is to lighten or soften shadows. Reflectors do exactly what their name says: reflect daylight, flash, or continuous light back onto the subject. They work like a subsidiary light source and the effects they produce are often referred to as fill light. The larger the reflector, the larger and softer the fill light will be. Where and when to use reflectors is entirely up to you, as shadows often enhance the overall effect of a food photo.

Gold Reflectors

Gold reflectors produce warm light and are rarely used in food photography, although this, too, is a matter of taste. The two shots on the opposite page show our previous sample subject captured using gold and silver fill reflectors. In this case, the gold reflector has a positive effect and enhances the look of the tartlets in the foreground. If you don't have a gold reflector, try using an old survival blanket to test the effect on your next shoot.

Silver Reflectors

I use silver reflectors more often than gold, but still less frequently than my beloved sheets of Styrofoam. A silver reflector produces clear but quite hard light without a trace of a color cast. See page 201 for instructions on how to make your own silver reflector. But before you do, check out the difference between the two photos on the opposite page. The one shot using a silver reflector has a much cooler look.

Remember, the larger the reflector, the larger and softer its effect will be. The photos here show how reflected light softens shadows and brightens the overall scene.

The intensity of a light source decreases with increasing distance to the subject, so moving a reflector toward or away from the subject increases or decreases the strength of its effect. For more details, see the Light-to-Subject Distance section below.

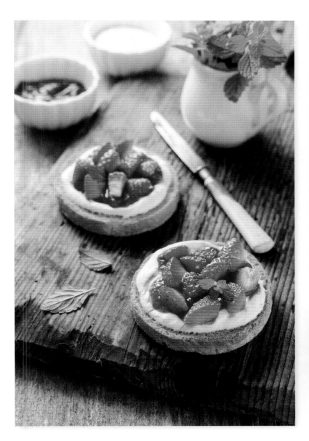

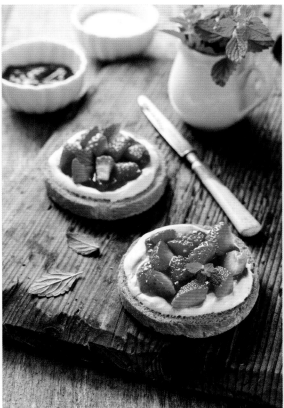

For this shot I positioned a gold reflector at front right. You can clearly see how the crust of the front tart is bathed in a golden hue.

ISO 100, 1/3 second, f/5.6, 100mm

Here I used a silver reflector to soften the shadows and brighten the image. The colors in this image are cooler.

ISO 100, 1/3 second, f/5.6, 100mm

Fill Reflectors

A sheet of paper, a piece of card, a sheet of Styrofoam, or anything else white can be used as a fill reflector. A purpose-built 5-in-1 reflector is ideal if you happen to have one handy. To get the most out of a reflector it needs to be placed directly opposite the main light, although this isn't always the best approach. You can vary the angle of the reflector and the distance between its surface and the subject to suit your taste. You can also use multiple reflectors. Keep experimenting until the interplay of light and shadow in your shot looks just how you imagine it should.

The upper right-hand photo below was captured using daylight only and shows obvious foreground shadows as a result. Using a reflector almost completely removes the shadow effect and brightens the entire scene.

Placing a reflector to the left produces a similar result. The lower right-hand photo shows the effect of adding reflectors on both sides—it looks too bland for my liking. I rarely use twin reflectors this way.

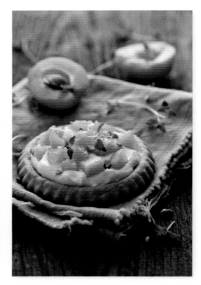

Left: The setup for the apricot tart without a fill reflector.

Right: The result shows obvious shadows in the foreground.
ISO 100, 1/20 second, f/5.6, 100mm

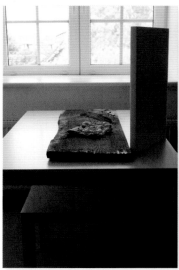

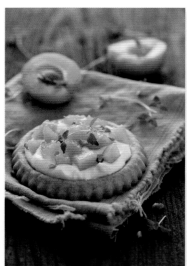

Left: The same setup with a fill reflector positioned at front right.

Right: The reflector reduced the shadows and brightened the entire scene.
ISO 100, 1/25 second, f/5.6, 100mm

Take time to test various reflector setups, and never underestimate the effect of varying the distance between the subject and the reflector.

Left: The same setup, this time with a reflector at front left.

Right: The effect is similar to that of placing the reflector on the right (previous page).
ISO 100, 1/20 second, f/5.6, 100mm

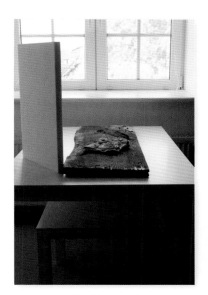
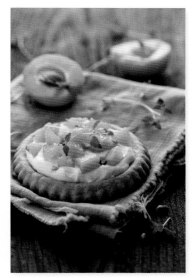

Left: The same setup with twin fill reflectors positioned to the left and right.

Right: This setup sharpens the shadow effect and significantly brightens the scene.
ISO 100, 1/25 second, f/5.6, 100mm

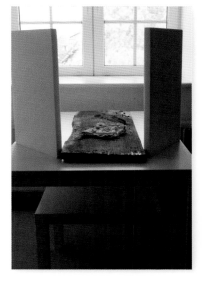
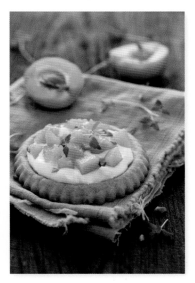

Mirrors

Mirrors are great for placing accents in food photos. A pocket mirror or even a fragment of a broken mirror is often enough to create a usable effect. Positioned carefully, a tiny mirror can effectively brighten a selected detail. As always, the key to success is experimentation.

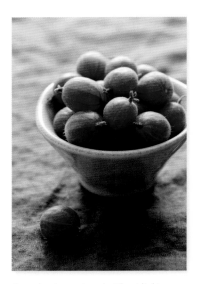

Gooseberries captured without light shapers.
ISO 100, 1/5 second, f/5.6, 100mm

Diffusers

Now that you know all about reflectors and how to use them to enhance your food photos, let's take a look at diffusers, another essential food photography tool. A diffuser is usually made of translucent white fabric—a bed sheet or a curtain will do just fine. A diffuser's job is to soften the incident light (the light falling on your subject). I will explain the difference between hard and soft light in the next section.

In addition to softening and scattering the incident light, a diffuser also increases the effective size of your light source (see page 32). And like a fill reflector, it also softens shadows. If you use a diffuser and a fill reflector, you will end up with virtually no visible shadows in your images. The following example demonstrates these effects. I captured the photo on the left in daylight only, which produced some very bright highlights on the gooseberries at the back and a strong shadow in front of the bowl.

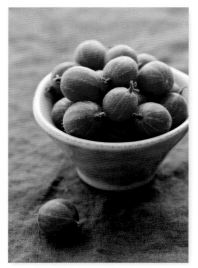

Left: The diffuser placed between the window and the subject provides more even lighting.

Right: The diffuser reduced the strength of the highlights on the gooseberries.
ISO 100, 1/3 second, f/5.6, 100mm

Left: The fill reflector on the right further softens the shadows and brightens the gooseberries.

Right: The new version of the same shot has even less shadow.
ISO 100, 1/5 second, f/5.6, 100mm

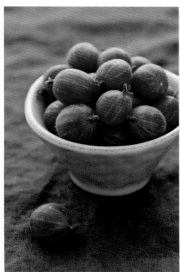

Combining diffusers with fill reflectors provides soft, even lighting.

I then placed a large circular diffuser behind the bowl, which reduced the strength of the high-lights and brightened the shadow in front of the bowl while simultaneously reducing the contrast between its center and edges. If you add a fill reflector to a scene like this, the shadows disappear almost completely and the subject will be very evenly lit.

Remember, the larger the diffuser, the softer the light it produces. You can use anything from a bed sheet or drape to a purpose-built softbox to produce this kind of effect.

Flags

A flag is a light shaper that absorbs light instead of reflecting it. You can make a flag by covering a reflector with black fabric or you can build your own (see page 201). Even a simple sheet of black construction paper fits the bill. Flags darken shadows and are really useful in situations when you need to produce a darker look, as illustrated in the next example. As with a reflector, the distance between a flag and the subject determines the strength of its effect.

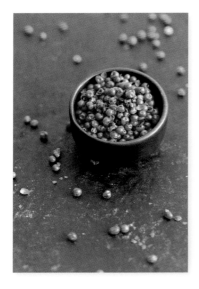

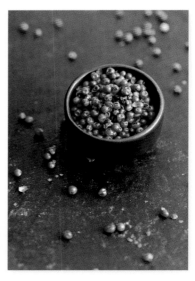

I captured these bright red berries without using a flag.
ISO 100, 1/2 second, f/5.6, 100mm

A flag on the left darkens this side of the shot.

The same shot with the flag added.
ISO 100, 1/2 second, f/5.6, 100mm

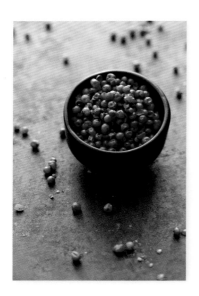

The same berries captured in back-light without a blocker.
ISO 100, 1/3 second, f/5.6, 100mm

A sheet of black cardstock acts as a light blocker.

The blocker produced much more even lighting.
ISO 100, 1/3 second, f/5.6, 100mm

The photo at top left on the previous page shows red berries captured in lateral daylight without light shapers, while the photo at top right was captured with a flag placed to the left of the subject. The additional shadow effect is obvious.

Bringing the flag closer to the subject would make the resulting shot even darker. Flags are also great for keeping the background subdued in backlit shots, as demonstrated by the example at the bottom of the previous page. The left-hand shot has a clear brightness gradient running from top to bottom. Placing a sheet of black card-stock behind the subject blocks some of the light from the window and reduces the strength of the gradient. As you can see, a flag can be used to darken or block incident light, which is why I often use them to give certain shots a darker, homespun feel.

Hard and Soft Light

As promised, this section takes a look at the difference between hard and soft lighting effects. Generally speaking, hard light produces obvious shadows, while soft light produces gentler shadows (or none at all). But what is hard light and where does it come from?

I captured the photo at top right under midday sun streaming through my window without the help of any light shapers. As you can see, this approach produced dark, unattractive shadows around the cup, and burned-out highlights showed up on its rim. This poor lighting setup is the result of shooting in direct, unfiltered daylight.

For the lower photo, I softened the hard light using a diffuser (a technique I explained in a previous section). Isn't the difference amazing? Note how using a diffuser extended the required exposure time. If you want to shoot food photos outdoors, always bring a diffuser or light tent with you. As its name suggests, a light tent is a prefabricated cube-shaped (or rounded) diffuser box that is quick to set up. Placing your subject inside a light tent softens the light coming from all directions.

As we discussed at the beginning of this chapter, flash behaves the same way as daylight if used without a softbox or diffuser, producing dark shadows and lots of contrast. If you like this kind of effect, make sure that your shadows still show some detail and don't get swamped in inky blackness. Note that direct sunlight is hard light and almost always requires the use of a diffuser to soften its effect.

This setup is lit by direct, hard sunlight, producing obvious shadows and blown-out highlights.
ISO 100, 1/125 second, f/5.6, 100mm

A diffuser placed in front of the window produced soft light with gentle shading and no irritating bright spots.
ISO 100, 1/60 second, f/5.6, 100mm

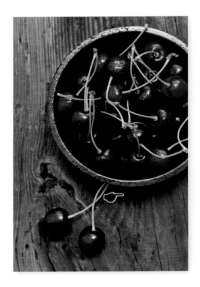 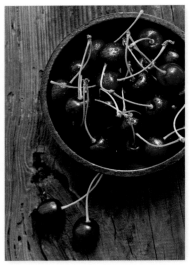

Left: The daylight lamp I used for this shot is positioned directly behind the subject. The shadows are short and don't intrude on the composition.

ISO 100, 2.5 seconds, f/8, 100mm

Right: Moving the lamp away from the setup produced longer, more obvious shadows and the cherries are less brightly lit.

ISO 100, 3.2 seconds, f/8, 100mm

Light-to-Subject Distance

The distance between your light source and the subject is critical to the effects of light and shadow in your food photos. To get a feel for how this works, try moving your table a little farther away from the window or your flash a little farther from the subject. You are sure to notice that the closer your light source, the shorter the shadows in your photo. The greater the light-to-subject distance, the longer the shadows and the greater their effect on the final composition.

To capture the left-hand photo above, I placed my daylight lamp right next to the table, which produced balanced light and short shadows.

For the right-hand shot, I moved the lamp to about three feet away from the subject. This made the shadow of the bowl much longer so that it takes up more of the surface area of the finished photo. This gives the overall lighting a less well-balanced look.

Angles of Incidence

Have you been taking photos while you read this book? Have you tried out different camera positions? If so, you are sure to have noticed the difference the angle of the incident light makes. When you work with artificial light, you can choose whether to light your subject from above or from the side. Check out the next two photos to see what I mean.

Altering the position of the lamp significantly changes the shadows and the overall lighting. The shadows in the upper photo are short and the light is evenly distributed across the frame. In

Left: The daylight lamp I used for this shot is positioned high up behind the subject.

Right: The shadows are short and the lighting is balanced and even.
ISO 100, 2 seconds, f/8, 100mm

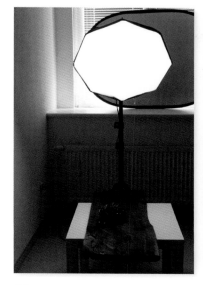

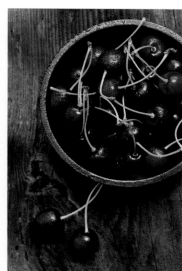

Left: For this version, I positioned the lamp much lower.

Right: The shadows are much longer and the final image has more contrast.
ISO 100, 2.5 seconds, f/8, 100mm

the lower photo, the rear portion of the subject is much brighter than the foremost part, and the shadow in front of the bowl is darker and plays a more significant role in the overall composition.

The lesson to be learned here is that the angle of incidence of your light can be used to produce distinct creative effects thanks to the influence this has on the size and shape of the shadows.

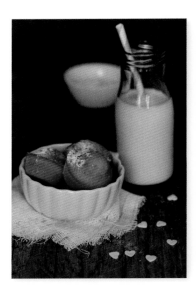
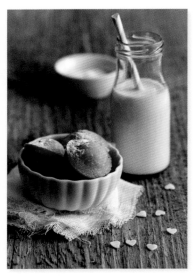

Left: I captured this shot using frontal light (i.e., the light source is behind the camera).

ISO 100, 1/15 second, f/7.1, 100mm

Right: Lateral light from three or nine o'clock is the best option for food photography beginners.

ISO 100, 1/13 second, f/7.1, 100mm

Light Direction

The direction from which the light is coming has a large effect on the final photo. As in every aspect of photography, your personal taste should determine the techniques you use, so it is up to you to decide how you set up your lights. As you gain experience, you will learn to see the pros and cons of each available option and it will become easier to determine the optimal approach to use for the subject at hand. In the following examples, I will use the numbers on a clock face to describe the direction the light is coming from. You are sure to come across these terms a lot in relation to food photography, so have fun experimenting!

Frontal Light from Six O'clock

This is an absolute no-no. Please don't ever light your food from the front. This produces a similar effect to that of built-in flash—shadows are cast behind the subject and the texture and contrast end up getting swamped, resulting in a two-dimensional and unrealistic-looking photo. The photo above left doesn't look particularly inviting, does it?

Lateral Light from Three or Nine O'clock

If you are just getting started with food photography, it is best to practice with lateral light from three or nine o'clock. It is up to you which side you use, although light from the left usually produces more balanced-looking results and light from the right produces more tension in a shot.

Lateral light is simple to apply and makes working with light shapers easier. Try placing a fill reflector opposite your main light or diagonally in front of the subject, or adding a flag or two.

Left: Diagonal light from behind provides attractive, balanced illumination.
ISO 100, 1/5 second, f/7.1, 100mm

Right: Backlight is often used to add texture and depth to food photos.
ISO 100, 1/5 second, f/7.1, 100mm

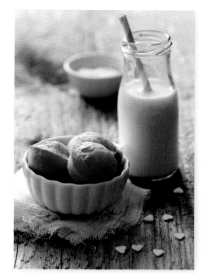
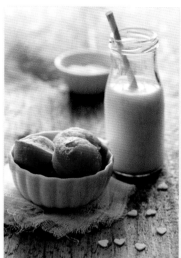

Lateral light produces photos with a highly three-dimensional look and emphasizes the texture, contrast, and details in a subject. Lateral light is also great for imbuing still lifes and food photos with a homey feel.

Compromising with Lateral Backlight from Eleven or One O'clock

Diagonal light coming from behind the subject is usually easiest on the eye and its intensity diminishes slightly toward the foreground. Here, too, light from the left (eleven o'clock) produces more balanced-looking results than light from the right (one o'clock). Whichever approach you take, you can add fill reflectors opposite your main light, as explained in the previous sections.

Backlight from Twelve O'clock

Backlight, or light from twelve o'clock, provides dramatic, high-contrast lighting. It is especially effective for capturing photos of drinks and food served in transparent dishes because it lights up the glass and gives the contents a glow of their own. In situations like this, you need to use a reflector to soften the contrast produced by the shadows cast in front of the subject. Backlight makes the side of the subject facing the camera dark, so you need a reflector to prevent the photo from taking on a silhouette-like appearance. The viewer should be able to easily identify the subject.

If backlight makes the rear portion of the subject too bright, use a flag as explained in the section titled "Reflectors, Flags, and Other Light Shapers."

Don't forget to compensate for potential camera shake. If you are shooting in weak light (for example, in the evening), you will have to use longer exposure times and a tripod to keep things steady.

Light at Different Times of Day

If you have already started using daylight as your prime light source, you are sure to have noticed that it has different effects on your photos depending on the time of day. The mood produced by daylight changes almost hourly. Do you have a favorite time of day or a favorite window that provides the best light?

Take the time to shoot at different times of day and study the effects this has on your food photos.

Preventing Unwanted Reflections

In food photos, artificial lighting often produces unwanted reflections in dinnerware, flatware, sauces, and other shiny details. Some reflections are small enough to ignore, but larger artifacts and burned-out highlights that show no detail at all can be distracting. Always use your camera's overexposure warning (if available) or Lightroom's Highlight Clipping feature to reveal overexposed areas (see page 170).

The photo at top left on the next page was captured in daylight conditions without using a diffuser. It shows obviously burned-out highlights on the blade of the knife that eclipse the rest of the subject. So how do we go about reducing this effect?

The simplest solution is to place a diffuser between the subject and the light source or position a sheet of black cardstock in such a way that the brightest reflections disappear. The problem with the second approach is that it produces darker shadows that alter the overall mood of the shot.

Alternatively, you can alter the angle of view of your camera, moving it up, down, left, or right until the reflections are reduced or disappear completely. Once you have found the right position, you can mount the camera on your tripod and begin shooting. With practice, you will develop an instinct for setting up your subject in the available light so that reflections are kept to a minimum.

I hope this chapter has helped you get to know light better. Maybe it even provided you with a "eureka" moment or two. Now it's time for you to perform your own experiments with light and light shapers.

Reflections can spoil bright spots in dinnerware, flatware, and sauces. The brightest of these form burned-out highlights that show no detail at all.
ISO 100, 1/5 second, f/5.6, 100mm

The Highlight Clipping feature in Lightroom highlights overexposed details in red.

A diffuser is a great tool for reducing unwanted reflections.

The diffuser has eliminated the over-bright reflections.
ISO 100, 1/4 second, f/5.6, 100mm

Holding a sheet of black cardstock above the subject has a similar effect.

Once again, the bright highlights have disappeared. This method is ideal for counteracting reflections in soups and sauces.
ISO 100, 1/5 second, f/5.6, 100mm

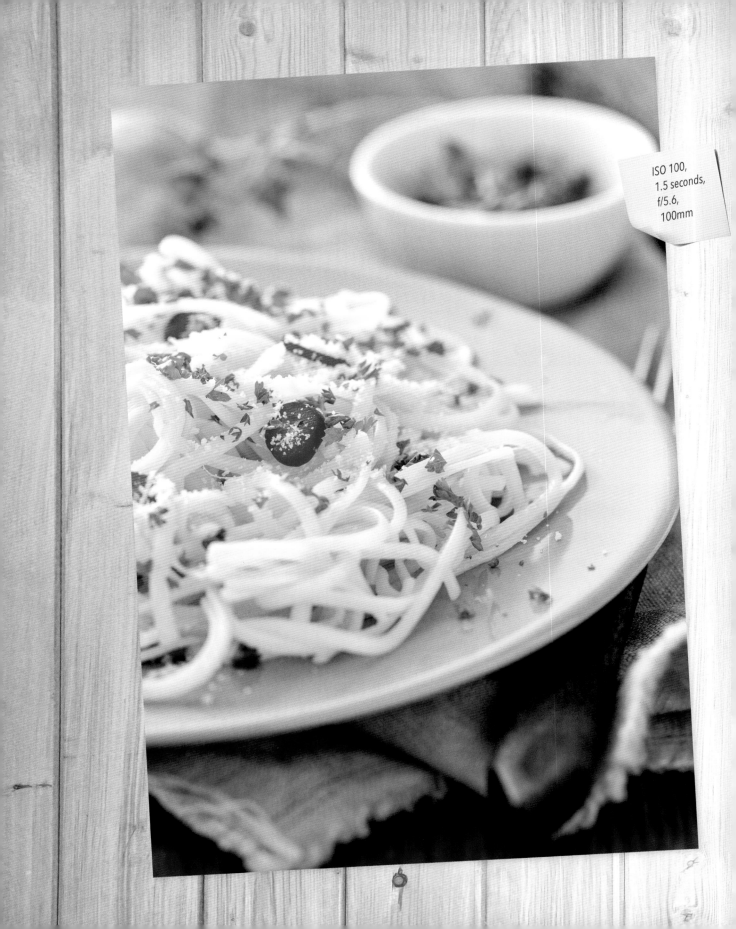

ISO 100,
1.5 seconds,
f/5.6,
100mm

CHAPTER 4
Image Design and Composition

In addition to the blood, sweat, and tears involved in preparing the food, the composition is crucial to the success of your food photos. A great food photo has to communicate a specific atmosphere and it has to be attractive and appetizing. Are you shooting a big breakfast made to sweeten the start of the day or a stew prepared to reward someone for a hard day's work?

It is essential to go into every shoot with a precise idea of how you want the results to look. With practice, you will develop your own style and a talent for composition and photo design.

There are plenty of ways to make your food photos expressive, exciting, lively, or calming. Never forget that photographing food is a highly personal pursuit that expresses your taste and individuality. Most importantly, the subject has to demand the viewer's full attention and must not be dominated by props or a poorly chosen background. At the end of the day, your results should satisfy you as a photographer and encourage your viewers to get cooking.

Start Slowly

To make getting started easier, I recommend that you practice on still-life subjects—ones that you don't have to prepare and cook, and that don't lose their luster while you work. Fruit, raw vegetables, herbs, and cookies are great static subjects to practice on, and I promise they won't talk back!

Portrait or Landscape Format?

Would you photograph a pitcher of homemade lemonade in portrait or landscape format? I'm willing to guess you would instinctively choose portrait format. Or how about a beautifully set table full of delicious dishes? Landscape format is the option to choose if you want to include plenty of detail. However, some subjects can be captured effectively using both formats, and as always, your approach will be determined by your personal preferences. Over the years, I have developed a distinct liking for portrait-format shots.

The advantages of portrait format are that it makes composing a scene easier, gives the subject more depth, and has a more dynamic look than landscape format. It is, of course, the best option when you are working with tall subjects and props.

When you are composing a shot, it helps to know how the finished images will be used. On the web, portrait-format images are usually displayed larger than their landscape counterparts. If you want to add a signature or recipe text to an image, it is easier to build extra space into a

Portrait-format shots are often used in magazines.
ISO 100, 1/13 second, f/5.6, 100mm

Landscape-format shots are more reminiscent of the way we view the world in general.
ISO 100, 1/10 second, f/5.6, 100mm

portrait-format composition. I will explain how to do this later in the chapter. Portrait format is often used in advertising because it makes composition simpler. The next time you are flicking through your favorite magazine, check out how many of the advertisement images were shot in portrait format.

Because we scan our surroundings horizontally, landscape-format images tend to appear calmer, more natural, and slightly static. However, a landscape-format image contains more detail for the brain to digest than a portrait-format image, so if you want to be sure of producing balanced-looking results, you have to take extra care when setting up landscape-format shots. Each prop plays a significant role.

Once again, there is no right or wrong option and the effectiveness of the finished image depends on successful design and composition. Try to follow your gut feeling when deciding which format to use—you will usually pick the right one instinctively.

Shooting Angles

Just as you can look at a delicious dish from a variety of angles, you can photograph it from a number of different angles too. The three most widely used views in food photography are eye level, bird's-eye (from above), and diagonal at 45 degrees. The angle you choose will depend on the subject and your personal preference. For example, pizza looks best if photographed from above, while a multi-layer cake looks much better when captured at eye level.

If you are not sure which option to use, take multiple shots of your subject from various angles and select the best image later on. You will quickly learn which angles are best suited to what types of food. Give yourself plenty of choices and take as many shots as your subject allows.

Always keep an eye on the interplay between light and shade in your shot. The accents and shadows vary depending on the angle from which you shoot.

Eye Level

Shooting at eye level means positioning your camera on the same level as your subject. This approach is ideal for photographing drinks, burgers, sandwiches, wraps, cakes, and other layered desserts. It offers the viewer a look inside the subject, clearly revealing the individual layers and emphasizing just how delicious the fillings are. Remember that the viewer will only be able to see the front of the subject, so concentrate on making the side facing the camera look really good. An eye-level view also allows you to shoot at wide apertures, which separates the subject visually from the background (see page 17). Furthermore, if you don't have access to a tripod, you can capture shake-free eye-level shots simply by placing your camera on the table.

An eye-level shooting angle offers an intimate view of the subject.
ISO 100, 1/4 second, f/5.6, 100mm

The downside of an eye-level view is that you have to put a lot of effort into designing the background because the surfaces beneath and behind the subject are visible. The surface beneath the subject can either contrast with the background or, as in this example, match it to enhance the overall mood. An eye-level view is less suitable for capturing food served in opaque dishes, pots, or cups because the container blocks the all-impor-tant view of the food inside.

Bird's-Eye View

A bird's-eye view provides an overview of the subject and its surroundings while empha-sizing the shapes of the individual elements. Images shot from above often have a highly graphic feel. The downside of shooting from a bird's-eye view is that it is more difficult to create a balanced composition (for example, see the cucumber soup shot detailed in chap-ter 6); although again, nothing beats practice!

If all the elements in your image are the same height, you can use a wide aperture and still keep everything in focus. You can shoot a subject arranged on the floor from a standing position using a 50mm lens, but you will need to use a stool or a short step-ladder if you shoot with a 100mm (or longer) lens. Floor-to-ceiling windows are ideal for lighting bird's-eye shots at floor level.

Shadows are generally more of an issue when you shoot from above, although their structure depends on whether you use direct or diffused light, as well as on the light-to-sub-ject distance (see page 50). Unless you want to deliberately use shadows as part of the com-position, be sure to use soft, even lighting for overhead shots.

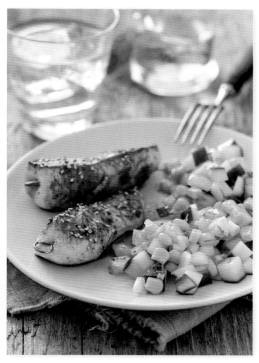

A bird's-eye view means you have to take great care arranging the subject.

ISO 100, 0.8 second, f/8, 50mm

A 45-degree angle represents the angle at which we see food when we sit down to eat, and works for virtually all types of food.

ISO 100, 1/4 second, f/6.3, 100mm

Shooting at an Angle

Shooting at an angle is a good compromise, and there is plenty of scope when shooting at angles between 30 and 70 degrees. This happy medium works for just about any dish and enables you to accentuate details on the front, sides, and upper surface of your subject while still giving a clear indication of its shape and size.

This type of shot is particularly easy on the eye because it utilizes the angle at which we see food when we sit down to eat. It usually includes some background detail, making it necessary to carefully arrange your other props. However, clever composition and carefully considered shooting angles also make it possible to shoot without using a dedicated background at all.

An angled camera position is great for closeups or when you have to shoot in a small space. Once you get going, you will quickly learn to judge which angles work best for which types of subjects.

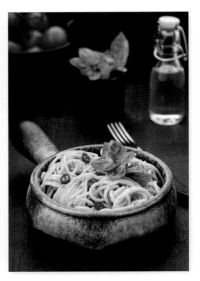

A closeup brings subject nearer.
ISO 100, 1/3 second, f/5.6, 100mm

A general view means you have to carefully arrange your background and props.
ISO 100, 1/5 second, f/5.6, 100mm

An overview shot requires great attention to detail in the arrangement of the individual elements of the composition.
ISO 100, 1/13 second, f/5.6, 100mm

Framing

Your three basic framing options are closeup, general view, and overview. How you frame your subject will depend on the type of dish you are photographing, your styling choices, the composition, and, of course, your personal preferences. If, for example, you have just cooked up a fabulous roast, homemade pasta, or intricate hors d'œuvres to surprise your guests, a closeup is probably the best option. Closeups are great when the dish has a single defining characteristic or if you simply don't have the time or inclination to style the shot. Closeups fill the frame with the real star of the show—your dish—and leave little or no space for a background or other details. This means you can concentrate on getting the exposure right for the food and forget about everything else.

Make sure that you set up your camera to produce sufficient depth of field. Too much blur makes a shot look abstract and makes it tricky for the viewer to identify what's on display. Plenty of depth provides clear definition and makes food look tastier.

A general view still concentrates on the dish but also includes some of the surroundings. The farther you move away from your subject, the more important styling becomes and the greater the role played by the background, flatware, dinnerware, and other props. Here, too, you need to capture enough depth of field to make the main subject easily recognizable.

Overview shots display a dish in the center of a complex composition that can involve an entire table or even a complete kitchen scene. These shots require a lot of effort to design and set up. The styling involved is an integral part of the shot and is key in creating the overall mood of the photo and communicating your message.

Positioning the Star of the Show

The most important aspect of food photo composition is positioning the main subject. Most beginners simply place the subject in the center of the frame and shoot. Unfortunately, the results often look more like a random snapshot than a planned food photo. Before you shoot, decide what is the most important element of your subject and where it needs to be placed to maximize the effect of the shot. Once you have made this decision, you can set up the rest of the composition around your "star."

If possible, remove your camera from its tripod and begin framing with the camera handheld. This gives you more flexibility while setting up the shot. Once you have found the right camera position, you can lock it in using your tripod.

In the Center

Simply placing the subject in the center of the frame often gives a photo a spontaneous, unplanned look. To make your composition more interesting, try leaving your subject on the central vertical axis but move it slightly up or down. This results in a photo in which the subject is still basically central, but there is an added design element. The further you move your subject along the central axis, the more exciting the resulting image will be. Be brave and go for a big shift!

A great way to emphasize the subject in this type of centralized composition is to arrange the other props symmetrically on either side of an imagined central line. Slight asymmetry—produced, for example, by positioning a fork on the left and a knife on the right—adds vitality to a shot without spoiling the overall feeling of symmetry.

The subject is positioned in the center of the frame, producing a calm, balanced image.
ISO 100, 1/20 second, f/3.5, 100mm

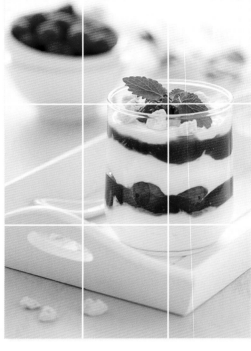

Shifting the subject up or down along the central axis adds vitality and creates tension.
ISO 100, 1/15 second, f/3.5, 100mm

I set up this composition according to the rule of thirds.
ISO 100, 1/10 second, f/5.6, 100mm

The Rule of Thirds and the Golden Ratio

If you find a central subject unattractive or simply dull, move it. The difficult part is deciding where to place it instead. The "rule of thirds" and the "golden ratio" are two easy-to-apply rules of thumb. The golden ratio is considered by many to be the ultimate compositional guideline, and most cameras offer a thirds grid that you can opt to display in the viewfinder or on the monitor. The grid divides the frame into nine equally sized rectangles using horizontal and vertical lines. All you have to do is position the subject (or its brightest or sharpest detail) on one of the intersections formed by these lines. The intersection formed by the golden ratio is in a similar position but is slightly closer to the center of the frame.

Positioning the subject according to the rule of thirds or the golden ratio produces a balanced image that radiates calm without appearing dull. Such a composition is easy on the eye and we are instinctively drawn to subjects placed this way. If you are unsure how to approach a particular composition, applying one of these rules will usually produce good results, or at least give you breathing space to concentrate on designing the rest of the shot.

In the photo at top right, I positioned the raspberry trifle on the right-hand vertical line with the mint leaf placed at the top-right intersection.

The Edge of the Frame

If you like your photos to be lively and vibrant, simply forget the rules and place your subject close to the edge of the frame. The further the subject is from the center, the more eye-catching the image will be. The edge you choose will depend on the way your shot is set up, but you can always try out multiple variations to be sure you get the best results. Shifting the subject toward the top of the frame creates an impression of lightness, whereas moving it toward the bottom gives it a heavier feel.

Applying this approach to small subjects creates so-called negative space in the rest of the frame, which provides a counterpoint to the subject. In such cases, the subject needs to be especially well defined (by way of brightness, color, or sharpness) to compete successfully for the viewer's attention.

Halfway Out of the Frame

If you are feeling really brave, try shifting your subject so that it is no longer completely visible within the frame. This type of effect often occurs automatically in closeup shots because the subject simply doesn't fit in the frame, but using this technique deliberately at greater camera-to-subject distances produces quite striking images.

Some people really like these kinds of compositions, while others find them confusing or even irritating. Whatever reaction you provoke, you have engaged the viewer's attention, which isn't always easy in today's image-driven world.

Left: Shifting the subject creates negative space.
ISO 100, 1/10 second, f/5.6, 100mm

Right: Paradoxically, moving the subject halfway out of the frame commands even more attention.
ISO 100, 1/10 second, f/5.6, 100mm

Tethered shooting techniques enable you to check focus on your laptop.

A Canon EOS450D/Rebel XSi in live view mode, which allows you to check focus and analyze your composition.

You can use the monitor zoom function to set the focus point manually.

Focus

In chapter 2, we learned how to use focus effects to steer a viewer's gaze toward a specific point within the frame. This technique involves using a wide aperture to emphasize in-focus details amid blurred surroundings. If you wish to present an overview of your scene with more details in focus, use a narrower aperture to create greater depth of field.

However, greater depth of field doesn't mean that everything in the image is automatically in sharp focus, but rather that a greater portion of the image will appear relatively sharp compared with the rest of the frame. Only objects located on the plane of focus will appear truly sharp. It is essential to focus precisely on the most important element of your composition.

To check focus, you can use the zoom function on your camera's monitor, connect your camera or memory card to your computer and view your images there (which involves a lot of effort), or use tethered shooting techniques to retain real-time control over your camera settings (see page 154).

Tethered shooting is when you use a cable to connect your camera to a computer where captured images are displayed in real time and saved to a hard drive instead of the camera's memory card. This enables you to check focus on the computer monitor and make any necessary adjustments immediately. I shoot almost exclusively in tethered mode, which saves time and is better for my nerves. See chapter 7 for more details on tethered shooting.

If you don't have access to a tethered shooting setup, most DSLRs have a live view mode that displays the subject on the camera monitor as it will be captured, enabling you to check and adjust focus as necessary. Live view gives me a great overview of my scene. It is much easier to analyze how a photo will look using the viewfinder or monitor than it is by eye.

For this shot, I focused on the foremost dish and left the background blurred.
ISO 100, 1/10 second, f/5.6, 100mm

Adjusting focus steers the viewer's gaze toward the dish at the back.
ISO 100, 1/10 second, f/5.6, 100mm

If you usually use autofocus, try switching it off and focusing manually. You will often find that this enables you to focus more precisely. Furthermore, if you shoot using a tripod, autofocus often gets in the way more than it helps because it has to refocus for every shot. When the camera is mounted on a tripod you only have to set manual focus once for each subject, and you can then alter the rest of your scene without having to refocus. It is rare that the position of one of the camera's autofocus points precisely matches the position of your subject within the frame, which means there is no way autofocus can find exactly the right setting.

In-focus and blurred details always go hand-in-hand, and the effects you can achieve depend on the lens you use (see page 5). Skillfully applied focus effects are a great way to emphasize or de-emphasize specific details and give your food photos extra polish.

The most important factor is striking the right balance between image areas that contain truly important details—the ones that really need to be in focus—and those that you can leave blurred.

Left: This shot, with its single design element, leaves plenty of space to add a recipe.
ISO 100, 0.6 second, f/8, 100mm

Right: Arranging the individual elements in a line guides the viewer's eye through the frame.
ISO 100, 0.6 second, f/8, 100mm

Steering the Viewer's Gaze

In addition to using focus effects to steer your viewer's gaze, you can also use the arrangement of the elements within the frame. This can take the form of a single point that grabs attention, a series of points that steer the eye back and forth, or an implied line that leads the eye through or around the frame. Whatever technique you use, the ultimate aim is to retain the viewer's attention. And to do this, you first have to get the viewer interested.

Attracting a Viewer's Attention

The human eye is attracted by details that are *sharper*, *brighter*, or *more colorful* than those surrounding them. Signal colors, letters of the alphabet, numbers, and other geometric shapes immediately attract attention in an otherwise abstract composition. In western societies, people tend to "read" images from top left to bottom right, the same way they read text. Photos that are designed to support this idea contain obvious details that lead the eye along this imaginary line. If, however, you wish to break with convention and challenge the viewer, you need to make one specific detail more attractive than the rest while making the top left-hand corner of the frame less attractive.

Individual points or lines within the frame, either real or suggested, help to attract and retain the viewer's attention.

Individual Points

Providing a single point of reference in an image is a popular technique that immediately gives the viewer a focal point on which to concentrate, but requires the use of plenty of negative space.

This effect can be further emphasized by strong contrast between light and dark or complementary colors—for example, a tomato against a green background or white currants on a piece of black-painted wood.

Lines

Real or imaginary lines give an image more vibrancy. The human eye tends to link identifiable points within a frame to form lines, so all types of lines are popular design elements. A line that runs from bottom right to top left provides a balanced viewing experience, although it is not always possible to construct such a pattern within a food photo. Lines lead the viewer's eye within the frame and emphasize the photo's feeling of depth.

Triangles

If you use elements within your composition to form a triangle, you will capture and retain your viewer's attention as their eye jumps from vertex to vertex. Triangular compositions are popular in many photographic genres and are widespread in the world of painting, and they can produce pleasing and interesting effects.

Circles

Arranging your scene in a circular pattern produces calm, highly pleasing images that allow the viewer's gaze to wander calmly around a central point.

Left: A triangular composition causes the viewer's gaze to jump from point to point.
ISO 100, 0.6 second, f/8, 100mm

Right: A circular arrangement of the main elements produces a calm, balanced effect.
ISO 100, 0.6 second, f/8, 100mm

Composing with Color

Food photos are usually in color. Although to avoid distracting the viewer from the real subject, the colors themselves normally play a secondary role. This is especially true of backgrounds and other props. It's best to avoid using too many different colors in a single photo because this creates an unbalanced composition. Try to select colors that complement the color of the food.

The color wheel popularized by Swiss painter Johannes Itten is an important tool in image composition. All colors in the visible spectrum are made up of a mixture of the primary colors blue, yellow, and red. Complementary colors are ones that lie on opposite sides of the color wheel, while analogous colors lie next to one another. Skilled use of these basic principles will enable you to produce fantastic-looking colors in your food photos.

Johannes Itten's color wheel

It is often a good idea to reflect the color of your main dish in additional elements in the composition, such as a napkin, a glass, or freshly cut flowers. If the dish itself is colorful, it usually pays to tone down the rest of the scene using achromatic colors such as white, gray, or black. To deepen your understanding of the color wheel, try printing one out and keeping it handy while you work.

The pastel green background contrasts beautifully with the raspberries in this shot.
ISO 100, 1/30 second, f/3.5, 100mm

Contrasting Colors

The more different two colors are, the more contrast they produce. Complementary colors offer the greatest contrast. The contrast between complementary colors increases their perceived brightness while preserving color balance. Some sample complementary color pairs that reinforce each other's brightness are green and magenta, red and cyan, and blue and yellow.

Other types of color contrast also play a role in food photography. These can be the contrast between warm yellow/red and cool green/blue tones or the qualitative contrast between different degrees of saturation (for example, a deep red subject set off against a pastel yellow background). Light-and-dark contrast between similar tones is also an effective compositional tool.

Tastes vary and there are no real limits to how you can use color in your food photos. The most important thing to note is that the brightest, most colorful, or most highly saturated element of your scene is the one that will attract the viewer's attention and determine the feel of the image. In other words, make sure the dominant detail is the one you wish to emphasize the most.

Green and blue are analogous colors that fit well together.
ISO 100, 1/6 second, f/4.5, 100mm

Cookies and cake usually have a brown base tone and contrast well with blue.
ISO 100, 1/2 second, f/5.6, 100mm

This shot demonstrates the effectiveness of a monochromatic, tone-on-tone composition.
ISO 100, 1/2 second, f/5.6, 100mm

Analogous Colors

To produce images with a calm overall look and feel, you are better off using analogous colors that harmonize rather than contrast with one another. Once again, you can use the color wheel to identify appropriate colors, this time by looking to the right and left of your main color rather than at the colors opposite. Using this approach produces results that are discreet and unobtrusive rather than bright and bold.

Monochromatic Composition

A monochromatic, tone-on-tone approach is another way to create highly pleasing effects like the one shown in the coffee bean still life at top right. To create a monochromatic effect, select a main color and use slightly lighter or darker tones of the same color for the rest of your props and the background. Black, white, and gray are neutral, achromatic colors that, in principle, represent grayscale values. They make great additional colors in a composition, but only as long as they don't create too much contrast with the main colors. For example, yellow is better combined with white than with black.

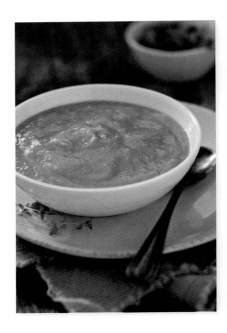

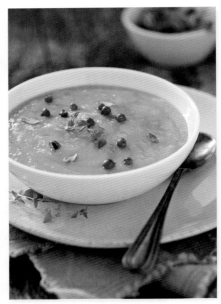

Left: This soup has a specific texture that can be accentuated using clever styling.
ISO 100, 1/25 second, f/5.6, 100mm

Right: Adding red berries and green herbs emphasizes the soup's texture and makes it more interesting to look at.
ISO 100, 1/20 second, f/5.6, 100mm

Adding Texture

A plain sheet of white paper is not particularly attractive to look at, but it immediately becomes more appealing if you cover it with black dots. In other words, texture is just as important as the other elements we have already discussed (and those that are still to come). Texture is an integral feature of the food, backgrounds, and props you use.

The example above shows how adding a couple of simple styling elements makes the rather dull-looking soup immediately more enticing and attractive.

The first example on the next page demonstrates the importance of background texture. Adding raspberries and pistachios enhances the texture of the delicious-looking chocolate pudding, but the background is simply boring. Adding a wooden background makes the shot much more interesting without reducing the appeal of the subject. Try using backgrounds made of different materials and with different patterns, and don't be afraid to experiment with random additional elements that loosen up the overall composition.

Negative Space

In contrast to positive space, which is filled with tangible objects, the term negative space describes the parts of the frame that contain no specific detail. Negative space is often used to deliberately steer the viewer toward the subject, and it also provides room for a watermark, recipe, or list of ingredients. Magazine photographers use negative space for text, but you can also use

it to produce spatial contrast that emphasizes the importance of the main subject. For example, imagine a tomato on a green-painted piece of wood, a lemon placed on a magenta-colored napkin, or fresh fish on a white wooden counter. Using this type of effect underscores the shape and color of the subject. However, you still need to make sure that it is the subject and not the background that remains in sharp focus.

The second example below shows how to utilize negative space to add text. Be aware that text always diverts attention away from the subject of a photo, thus altering its visual effect.

Left: The white background has no texture and makes the image quite dull.
ISO 100, 1/5 second, f/5.6, 100mm

Right: Using a textured wooden background makes the image much more interesting.
ISO 100, 1/5 second, f/5.6, 100mm

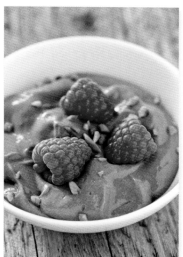

Left: This shot of a pot of pesto and thyme leaves has plenty of negative space.
ISO 100, 0.8 second, f/7.1, 100mm

Right: One way to use negative space creatively is to add recipe text.
ISO 100, 0.8 second, f/7.1, 100mm

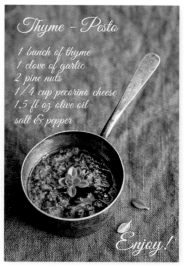

Capturing a Mood

Even though you now know all about color, composition, and camera positions, there is still more to learn. In addition to all the factors already mentioned, the mood is another key aspect of every great food photo. Put very simply, the two basic types of food photo that I distinguish between are "bright and airy" and "dark and rustic."

Images composed of elements such as dark wood, antique flatware, and stoneware cups communicate a solid, rustic, almost mystical feel, while white plates, highly polished flatware, bright backgrounds, and plenty of light convey a bright, airy, lighter-than-life feel. Keep an eye out for suitable props at garage sales and flea markets. You can usually pick up some useful bits and pieces for just a few dollars.

Always consider what backgrounds, props, and lighting mood best suit the dish you are photographing. Rich food, starches, and exotic herbs are all ideal subjects for portraying in darker surroundings, while lighter spring and summer vegetable dishes cry out for lighter colors. Using the seasons or climate from your recipe's country of origin as a guide is a surefire way to get great-looking results.

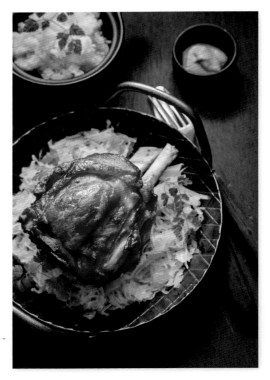

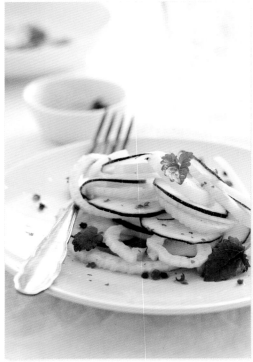

The prime characteristics of a rustic-style scene are dark colors and props with a used look.
ISO 100, 0.8 second, f/6.3, 50mm

White-on-white is a great color scheme for giving photos a light, airy feel.
ISO 100, 1/8 second, f/5.6, 100mm

Creating a Feeling of Depth

Even if you have taken great care setting up your subject, there is often still a feeling that something is missing when you view your first few photos. Certain angles of view and compositions can easily make food subjects look bland, so it is important to create a feeling of depth in your images. This is easiest to produce if you use props that partially cover each other. Don't be scared to populate the foreground, the middle ground, and the background with suitable objects.

Because food is often served on flat plates, it is important to add taller elements such as a vase, cup, or jug to the scene, as shown in the example below. You can also create similar effects by using the upper portion of the frame as negative space or switching to portrait format.

Tall props give a scene a relaxed look and a feeling of depth.

Food photos that don't include props of varying heights often look bland and one-dimensional.

ISO 100, 1 second, f/5.6, 100mm

Placing a taller object in the background adds depth to a scene.

ISO 100, 0.8 second, f/5.6, 100mm

Left: Setting up and capturing raw ingredients in a still life is an exciting challenge.
ISO 100, 1/5 second, f/5.6, 100mm

Right: Subjects that don't quickly dry out or lose their luster are ideal for practicing. This example shows a tomato salad in a rustic setting.
ISO 100, 1/3 second, f/7.1, 100mm

Practicing Image Composition

The great advantage of still life photography is that you can take plenty of time setting up each shot without running the risk of your subject drying out or collapsing before you are ready to press the shutter button. Still lifes are ideal for food photography beginners because they allow you to practice image composition and take the time to get to know your camera and the way its settings affect your results.

Why not shoot photos of the ingredients you plan to use in a soup or a salad before you actually prepare it? Setting up raw ingredients so they look appetizing is the perfect challenge to get your creative juices flowing.

Skillful use of light and shade can give still lifes a painterly look and feel, and rustic-style still lifes in particular are easy to post-process in Lightroom. The processing steps I applied to the example shown here are described in detail in chapter 7 (see page 164). You are sure to find that setting up still lifes can be just as complex and time-consuming as constructing "regular" food photos.

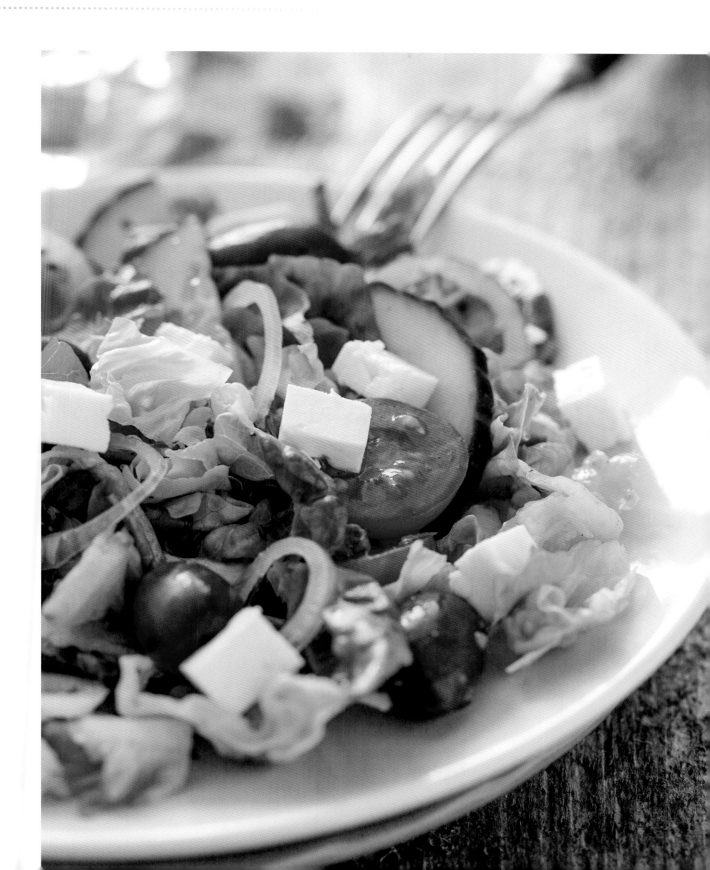

ISO 100
1.3 second
f/5.6
100mm

CHAPTER 5

styling

For many people, styling is the most exciting part of a food photography shoot. Along with the right light, styling is the most important factor in a successful food photo. It doesn't matter how much love and care you put into preparing a dish, if you don't photograph it with the same attention to detail, you won't be happy with the results, and neither will your viewer. And viewer satisfaction is what we are after, right?

Food photography styling doesn't just mean serving an exquisite dish—you also have to select the right props to give it the shine it deserves. Mastering these twin skills takes time and practice, and requires strong nerves. Even after all these years I am still practicing and I still make plenty of mistakes—that's all part of the fun!

Frank Weymann (www.foodstyling-weymann.com) is one of my favorite food stylists and his images always look perfect. Perhaps you have already found a great food photographer to learn from. If you haven't, now is the time to start looking. If you want to know why now, skip to chapter 10.

In this chapter, I will give you tips on how to develop your own food photography style. I will explain what a styling kit is and how to use it, and we will take a look at props and why crumbs, splashes, and used dinnerware are an integral part of the food photo experience. Curious? Then let's get started.

Inspire your viewers! Your photos should get people thinking up stories to fit the depicted scene.

Styling Concepts

So what is styling all about? Its basic purpose is to make a tasty dish look even tastier and, ideally, forge a direct route through the viewer's eyes and mind to the salivary glands. In other words, we want to make people's mouths water.

When you are starting out, it is a good idea to practice on room-temperature dishes. These are often easier to style and give you more time to get things looking right. Try out your skills on a plate of raw vegetables, a jar of jam, a piece of cake, or a sandwich.

Becoming a Storyteller

Great food photos tell a story. A photo of a cut cake immediately makes the viewer wonder who ate the missing piece. And who took a bite out of that cookie? Photos like this lead the viewer to invent stories to fit the image.

The days of immaculately styled, technically perfect food photos are over. Authenticity, plausibility, and reality are on trend, and today's food photos often include previously unthinkable details such as empty plates, half-eaten food, used flatware, half-full glasses, and so on.

Next time you head out for a picnic with your family you will not only get a lungful of fresh air, you will also find plenty of fresh fodder for your camera. If you have never photographed food in a field, it's high time you did.

If you are shooting outdoors, always take a small diffuser and fill reflector with you. A sheet of white paper or a white cloth will do fine.

If you have your own vegetable garden or access to someone else's, fresh produce makes a great subject for food photos. And you don't have to wash and chop your vegetables before you begin shooting either—earthy-looking food can be just as appetizing as a finely prepared dish.

The right-hand photo on the opposite page was post-processed using a preset. For more details on this technique, see chapter 7 (page 174).

Unconventional subjects like this empty plate add variation to your photos.
ISO 100, 1/2 second, f/6.3, 100mm

An outdoor shot provides a great contrast to your regular indoor photos.
ISO 200, 1/800 second, f/6.3, 100mm

If you have a vegetable garden or window box, the produce makes a great subject.
ISO 200, 1/200 second, f/4.5, 100mm

Choosing a Theme for Your Project

When you start out you will probably photograph anything that looks nice, or things you like to eat, or all those recipes that you always cook or have always wanted to cook. This is a great approach and gives you plenty of scope for developing your own ideas and food photography style. In time, you will discover which techniques and stylistic devices you like best.

However, once you have found your rhythm you are sure to want more, and this is where the concept of projects comes into play. This means giving yourself a specific task and spending time planning and executing it. Projects can be large or small, from a calendar to a cookbook or even an exhibition.

This shot is designed to convey the feeling of the season.
ISO 100, 1/4 second, f/5.6, 100mm

I used props I found at a flea market to create this rustic-style shot.
ISO 100, 0.6 second, f/5.6, 100mm

To get you started, here are a few suggestions for project themes:

- The seasons

- Regional or national specialty food

- Matching colors

- The shape of food

- New perspectives

- Lifestyle ideas like vintage, down home, back to nature, and so on

Once you have picked a theme, all of your props and accessories have to fit in with it. A polished silver spoon doesn't work in a rustic-style photo, and a plastic dish will spoil the mood in a photo showing strawberries or some other natural product. The photo at top left shows a shot from a project about the seasons. The wooden background and the sackcloth props underscore the underlying aesthetics.

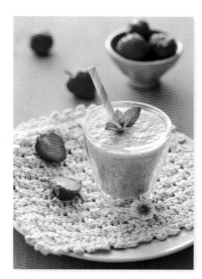

Left: This shot is based on a color theme and includes a couple of contrasting accessories.
ISO 100, 1/5 second, f/5.6, 100mm

Right: An overview of the setup.

Colors make a great starting point for a food photo project. If you already have a favorite color, why not start there? Things get even better if you have a favorite type of food that matches your favorite color. I love pink and I instinctively avoid blue and yellow. For a pink-lover like me, a delicious-looking strawberry milkshake with a matching background and a couple of hand-picked accessories is an obvious subject. Note that not all of your props have to match the base color, and too much of a single tone is tough on the viewer anyway. A good rule of thumb is to make sure that at least two-thirds of the objects within the frame match your chosen color. If you don't have a suitable background, make your own. For more details on building your own backgrounds and props, see chapter 9.

Props

In a food photo, props are all objects that aren't actually part of the food. Virtually anything you find in your kitchen, your house, your shed, or in the garden can be used as a prop. All you have to do is stick to your chosen theme and tell a compelling story—there are no limits to where your imagination can take you.

Backgrounds

The background is just as important as the subject and plays a major role in creating the mood in a food photo. Color is a critical factor in the background. I recommend that you build or buy neutral white and dark gray or black backgrounds (the latter preferably made of wood)—you will need these on a regular basis. These two basic backgrounds will enable you to quickly conjure a "bright and airy" or "dark and rustic" atmosphere.

When painting your own backgrounds, be sure to use colors that are likely to complement the colors found in food. For example, a bright red background is distracting and diverts the viewer's attention away from the subject. On the other hand, a light pastel pink background (yup, pink again!) is ideal for shots of cookies, pastries, and desserts. You can purchase suitable wood at a hardware store, where you can also find tongue-and-groove and plywood offcuts. Some of the best food photo backgrounds—vintage planks, old tabletops, doors, closets, and so on—can be found at recycling centers.

If you like DIY projects, you can make great backgrounds from the boards in a used pallet or shipping container. Maybe your own kitchen table is exactly the background you need? Try it out and see.

If you aren't into wood, try using wallpaper, ceramic tiles, newspaper, a cookie pan, packing paper, baking paper, a tablecloth, a blackboard, slate, placemats, napkins, paper towels, cardboard, paper, or whatever. As you can see, there are no limits.

In the photos below I used an old cookie pan for the cherries and a piece of felt in the shot of the oregano. You don't have to use wood if you don't want to. Take a look around your home and see what you can find to serve as a background for your photos. If you have hardwood or tile floors, they might be just the prop you are looking for.

> *Make sure your back-ground doesn't compete with the subject for the viewer's attention. A background should always enhance a photo, not dominate it.*

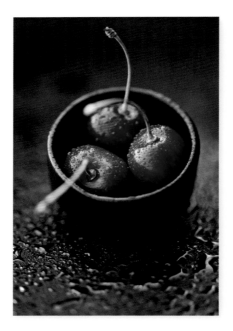

The background in this shot is an old cookie pan that I bought in an online auction.
ISO 100, 1/4 second, f/2.8, 100mm

The background here is a piece of leftover felt.
ISO 100, 1/4 second, f/5.6, 100mm

Left: A collection of used and new flatware provides plenty of options for styling.

Right: Fabric remnants, hand-written labels, and string are all great additional props that can be used in many different situations.

Fabric, Ribbons, and Labels

If you use fabric for your background, make sure it is smooth. If necessary, nail it to a wooden frame to keep it taut. Small pieces of leftover fabric and napkins make great additional props in all sorts of food scenarios.

You can use any kind of fabric, be it a tablecloth, towel, bed sheet, jeans, T-shirt, or anything else you happen to have lying around. If you like online auctions, keep an eye out for packages of remnants. These are often available at bargain prices and sometimes contain really valuable items. Keep one or two pieces of plain colored fabric and one or two striped pieces handy.

Ribbons and string make great accessories too, whether single-colored or patterned, and hand-written labels on jelly jars or dips give your homemade foods extra charm.

Flatware

Matte or polished? Plastic or metal? Antique or new? Flatware is just as important as your dinnerware, which I will discuss in the next section.

As with other props, you need a selection of different styles of flatware, including matte for rustic shots and polished for brighter shots. Plastic and ceramic flatware has its place in food photography too. I regularly visit flea markets and garage sales where there is always a bargain to be found. If, unlike me, you are good at making deals, you can usually knock the price down even further. If there are no markets or sales nearby, you can always search for new and used flatware on eBay or Etsy.

It's best to place flatware on a diagonal, rather than at a 90-degree angle to the rest of the scene.

Left: A selection of plates, cups, glasses, and bowls is an essential part of every food photographer's gear.

Right: Small pots, pans, and casserole dishes are ideal for filling a shot.

Plates, Cups, and Glasses

Although my cellar is full of stuff that I have collected over the years, you really only need a few carefully chosen props to create endlessly varied food photos. Neutral white dinnerware enhances just about any food photo, but you need to be careful if you use patterned plates and dishes because these tend to distract the viewer and break up the composition. Colored dinnerware is fine, especially if you use it as part of a color concept.

Small cups, plates, and glasses are easier to integrate into a scene and fill than larger ones, and you can also fit more of them into a shot. Matte-glazed and terra cotta dinnerware is ideal for preventing unwanted reflections. Food photographers have a reputation for being prop hunters—we're always on the lookout for new accessories, and it is easy to collect too much stuff. If you can, set up a rack or box containing your props near your favorite shooting space. This saves you from having to search the whole house for a particular plate when you are in the middle of a shoot.

Pots, Pans, and Baking Trays

Pots, pans, and even that old cookie tray you inherited from your grandma make great props. Again, a varied selection is key to creating interesting photos, although you will probably have fewer options if you are just starting out. But believe me, if you find yourself getting into food photography in a big way, sooner or later you will start collecting and your family will have to share their space with your props.

As an alternative to buying everything yourself, try borrowing suitable props from friends and neighbors. My friend Erika was amazed when I told her I could really use a scruffy old pan that she was planning to throw out. Seek and you shall find.

Flowers and Herbs

Flowers? Of course you can use flowers. Blossoms, twigs, and herbs make great props too. Imagine a cherry dessert topped with a real cherry twig, or strawberries garnished with blossoms from the bush. It's little touches like this that make a good food photo great. Herbs, too, are indispensible when it comes to styling food photos, and flowers make great background details in shots of a dressed table. Styling your scene gives you the perfect opportunity to get creative—just make sure you don't unintentionally include poisonous garnish such as poison ivy leaves or mushrooms in your shots.

Starter Kit: 13 Must-Have Food Photo Props

This is a list of the things every aspiring food photographer should have on hand during a shoot:

- Cups
- Dessert plates
- Salad plates
- Small bowls
- Medium-sized bowls
- Glasses
- A glass background
- A small wooden cutting board
- A set of polished flatware
- A set of rustic flatware
- Light- and dark-colored backgrounds
- Fabric (tea towels, remnants, and the like)
- Straws

Using just these accessories you can mix and match to create great-looking, varied food photos. You don't have to use white dinnerware right from the start. Grandma's old brown dinner set is fine for your first few experiments. I admit to having six racks full of props that I have collected over the years, but you only need a few bits and pieces to get started.

Flowers and herbs make great finishing touches in all sorts of food photos.

Keeping your styling tools in a small box or makeup case saves you from having to search for them every time you begin a new shoot.

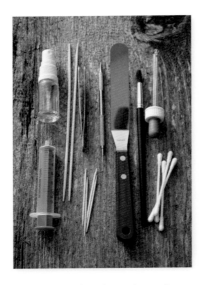

These are just a few of my styling tools, which I store in a box near my set.

Tweezers are ideal for positioning small props and fine-tuning details.

A pastry brush is perfect for getting rid of unwanted crumbs or oiling food to keep it moist.

Sample Styling Kit

Alongside your props, these are the things you will need to help you set up your shots. You are sure to have many of these around the house already. My personal styling kit includes:

- Scissors
- Tweezers
- Q-Tips
- Paper towels
- Various clips
- Tacky Wax or modeling clay for steadying props
- A towel
- Gloves for preventing unwanted fingerprints
- Spray bottle for creating water droplets and keeping food moist
- A sharp fruit and vegetable knife
- Toothpicks
- Syringes

- Glycerin

- Eyedropper

- A spatula for smoothing toppings, sauces, and the like

- Dentist's tools for fine-tuning a scene

- Pastry or basting brush for oiling food

- Wooden knitting needles or skewers

- Wooden blocks to support props or to use as dummies

These are the things I use, but your personal list will include other items as well, and it's sure to grow longer the more you shoot. Start building up your own styling kit now.

Working with Dummies

Dummies are placeholders that replace food or parts of food that would melt or fall apart if you used the real thing to set up your shot. For example, imagine you are shooting ice cream in summer but you need to make some alterations to the lighting—if you take too long, your delicious subject will quickly turn into soup.

This is where dummies come into play. To get your lighting right, your dummy and the actual subject need to be similar in size, color, and shape. For example, if you are making a photo of vanilla ice cream, a black napkin is not the right dummy to use.

Left: This shot shows a crumpled napkin used as an ice cream dummy.
ISO 100, 1/5 second, f/7.1, 100mm

Right: After I set up my lights, I substituted real ice cream for the napkin dummy.
ISO 100, 1/5 second, f/7.1, 100mm

 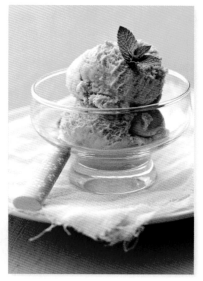

 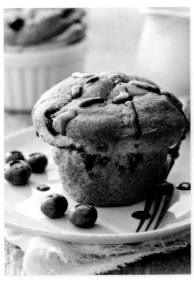

Left: Using a syringe to apply chocolate frosting.

Right: Frosting and sauces look much better if they are applied carefully and sparingly.
ISO 100, 0.8 second, f/7.1, 100mm

A dummy is ideal for testing various setups and checking the interplay between light and shadow on set before you position the real star of the show. Fabric remnants and napkins make quick, easy-to-deploy dummies.

And by the way, can you see the burned-out highlights in the bottom of the glass in the left-hand test shot on the previous page? The trick I used to get rid of them is explained in chapter 8 (see page 189).

Keep your dummies in a separate box instead of throwing them out. This way, you can use them time and again in different situations.

Styling Tips

This section lets you in on some of the tricks of a professional food stylist's trade, including the importance of elevation and the benefits of adding baking paper to your plates. In the next chapter, I will put everything we have discussed so far into practice in a sequence of hands-on food shoots, which you can use to hone your own technique.

Getting Sauces Right

Getting sauces in precisely the right position on salads, desserts, and main courses is a real art. If your attempts to add sauces to your subjects end in chaos, try using a 5ml or 10ml syringe to apply them (see the section on styling kits). Small syringes are easier to handle and they enable precise application of all kinds of liquids.

Pancake Rings

Pancake rings are great for shaping portioned salads and other loose dishes. Simply place the ring where you want your subject to be and fill it with food. If you remove the ring slowly and carefully, the food will remain in shape where you put it. Now all you need to do is add some herb garnish to create a mouth-watering photo.

Using Water to Keep Things Fresh

Fresh fruit and vegetables quickly start to dry out and look unappetizing when you spend time setting them up for a shot. To keep them looking fresh, use the spray bottle from your styling kit to moisten them. The difference is immediately obvious.

Fresh fruit and vegetables stay fresh longer if you store them in freezer bags in the crisper section of your fridge. To keep salad crisp and fresh-looking, wrap it in moist kitchen towels before you bag it and put it in the fridge.

The Lemon Juice Trick

Freshly cut fruit quickly turns brown when exposed to the air, which makes it tricky to capture photos of fruit salads. The solution is simple: to keep cut fruit fresh, put it in a dish of cold water with a splash of lemon juice.

Freshening Up with Cooking Oil

Meat and fried vegetables dry out fast, even if you are well prepared and shoot quickly. Dry-looking food is really unappealing, so to prevent this from happening, grab the pastry brush from your styling kit and some oil from the kitchen (light-colored cooking oil is best) and use them to give your food a fresh new shine.

Funneling Drinks

Filling glasses for a food photo can be a lot trickier than you think. It's amazing how ugly even tiny splashes on the side of a glass can look. The solution to this conundrum is to use a funnel to fill your glass. This prevents splashes and is better for your nerves—simple but effective. If you need to top off liquids while you shoot, use an eyedropper.

This bowl of berries looks okay, but there is still something missing.
ISO 100, 1/4 second, f/5.6, 100mm

Adding a few drops of water makes the berries look even more appetizing.
ISO 100, 1/4 second, f/5.6, 100mm

Getting rice to look good can be quite tricky.
ISO 100, 1/10 second, f/6.3, 100mm

Use a small bowl or an ice cream scoop
to shape a portion of rice.
ISO 100, 1/10 second, f/6.3, 100mm

Herbs and spices give any food photo that
extra something.
ISO 100, 1/10 second, f/7.1, 100mm

Rice Scoop

Rice and mashed potatoes are really tricky to serve attractively. However, you can use an ice cream scoop or a small bowl to give these foods shape and arrange them alongside your other ingredients. Dessert dishes or small drinking glasses work too, but an ice cream scoop is still my favorite tool for getting rice to look just right.

Herbs and Spices

When it comes to garnishing freshly prepared food, herbs and spices are an essential part of the mix. Fresh herbs give any dish extra pizzazz, and their shapes and colors add texture to just about any food composition. Common spices such as fresh peppercorns and sea salt or simple staples like French bread also add style to soups, salads, stews, and a host of other dishes.

Never leave fresh herbs lying around at room temperature because they tend to wilt quickly and lose their flair. To keep herbs fresh while you set up your shot, cut off the ends of the stalks, stand them in water, cover them with a plastic bag, and put them in the fridge until you are ready to shoot.

Less is More

Always use small portions for your food photos. These look better, are simpler to set up, and are easier for the viewer to imagine eating.

Left: Plastic ice is indistinguishable from the real thing.

Right: Artificial ice cubes make cold drinks irresistible.
ISO 100, 1/2 second, f/7.1, 100mm

Artificial Ice Cubes

If cold drinks are part of your repertoire, sooner or later you will end up using artificial ice. Like anything else, plastic ice cubes are available in a range of prices, but it is worth paying a little more for really authentic-looking cubes. These not only look good, but you can also use them to keep slices of lemon and other drink accessories in place. Sounds cool, don't you think?

Use Only The Best Ingredients

Once you have found a recipe you wish to photograph, make sure you buy only the very best ingredients. There's nothing more annoying than finding moldy strawberries at the bottom of the box when you are setting up your shot.

Increasing Depth

As discussed in chapter 4 (see page 75), using multiple levels contributes to a feeling of depth in a food photo. If you shoot at eye level, it helps to give the viewer an idea of what's going on in the rest of the scene beyond the main area of focus. If necessary, use moist kitchen towels or wooden blocks to raise the rear part of the food and bring it into the overall picture.

Contrast

As discussed in chapter 4, contrast can work miracles. A basil leaf strategically placed on a bowl of tomato soup or some carefully scattered herbs on your crostini gives the resulting image a much-needed finishing touch. Add berries to waffles or pine nuts to a blueberry dessert. Tiny details like these make your photos more attractive and thought-provoking.

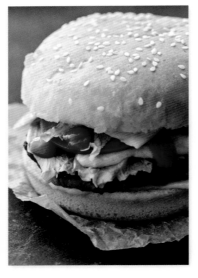

Left: Toothpicks are the secret to perfect-looking burgers, sandwiches, and subs.

Right: The toothpicks are invisible in the finished photo.
ISO 100, 1/8 second, f/7.1, 100mm

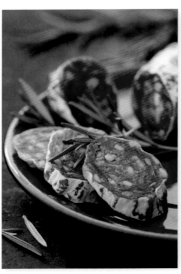

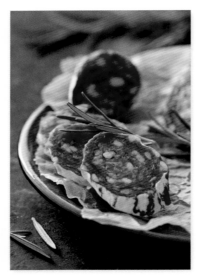

Left: The brown plate adds color but lacks texture.
ISO 100, 1/8 second, f/7.1, 100mm

Right: A piece of crumpled baking paper makes the background less severe and adds texture.
ISO 100, 1/8 second, f/7.1, 100mm

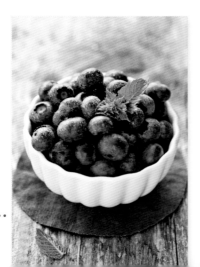

Left: Repeated shapes give a food photo a highly balanced feel.
ISO 100, 1/13 second, f/5.6, 100mm

Right: Drips and splashes in the right places make a food photo much more interesting and tantalizing.
ISO 100, 1/4 second, f/5.6, 100mm

Toothpicks

The fillings in burgers, sandwiches, and subs often try to escape while you work and can get really annoying. Toothpicks solve this problem by keeping everything in place while remaining invisible. Remember to remove them if you eat your subject after the session!

Baking Paper Adds Texture

If a plate or background is too smooth or lacks texture, crumple up a piece of baking paper, smooth it out by hand, and place it on your plate or background before you arrange the food. Can you see the difference this makes?

Repeated Patterns, Colors, and Shapes

Cookies on a circular plate, waffles on a checkered tablecloth, and strawberries in a red bowl are just a few examples of how you can use repetition to give the viewer's eye something to grab onto. Try it out on your next shoot. In the shot of the blueberries on the previous page the circular placemat and bowl mirror and underscore the shape and color of the subject.

Go Ahead, Make a Mess!

If you aren't extremely careful, it is very easy to drip sauce on your table or a plate; or perhaps some sauce has escaped and is dripping down the side of its jug. Instead of getting uptight and removing every drop and splash, try integrating "accidents" into your composition. The effect is often more authentic and the resulting photo looks less sterile. Used sparingly, deliberate drips and splashes can add vitality to a food photo; but don't overdo it—too much mess just ends up looking chaotic.

Odd Numbers

An odd number of objects makes a photo more appealing. Three cookies, cakes, or candies are always better than four. The only exception is when you are deliberately striving to create a symmetrical composition in which precision is the key element.

Garnish Sparingly

Never overdo your garnish. Added details are there to enhance the subject but mustn't steal the show. Less is often more.

If You Like It, Do It

All the tips and tricks we have looked at in this chapter are aimed at boosting your creativity. You can use any or all of them in your photos, or simply use them as a jumping-off point for your own experiments. Follow your instincts—who knows, maybe you, too, can become a trendsetter.

Seven Quick Styling Tips

- The point of styling is to enhance the visual appeal of the subject

- Always consider the camera's viewpoint when styling a shot; if necessary, get down to camera level when making adjustments

- Add texture to your subject wherever you can

- Don't overdo colors—let the food do the talking

- Always remain authentic

- Never overcook your food

- Always style your shot on set

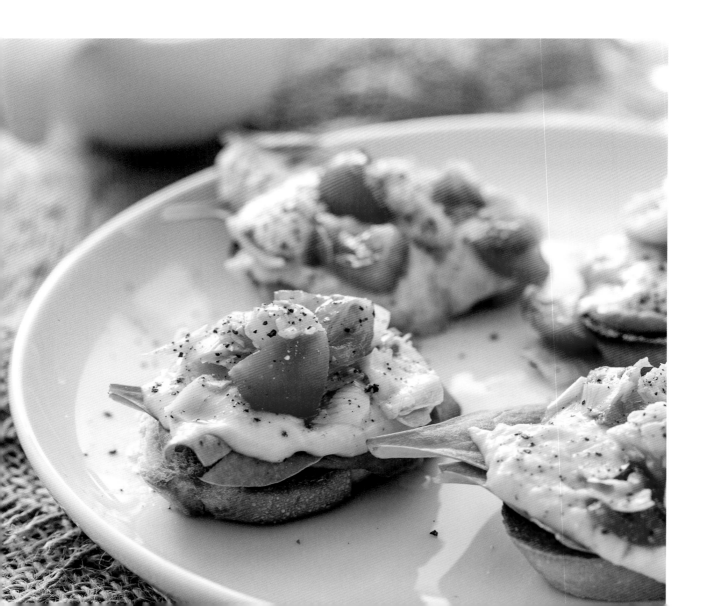

Including a human element often makes a food photo more appealing.
ISO 640, 1/80 second, f/5.6, 100mm

Photographing the preparation stages helps tell your story.
ISO 400, 1/60 second, f/2.8, 100mm

Including People in Your Images

If you are anything like me, you are sure to have loads of images stored on your hard drive that are still missing a certain something. And I'm not talking about an extra basil leaf on your bruschetta or the cherry on a cake—I'm talking about people. Grab your husband, wife, boyfriend, or girlfriend and turn them into extras on your set.

Get someone to bite into your freshly cooked burger (after you have photographed it fresh) or cradle your lovingly decorated cake in their hands, or perhaps simply take a picture of someone tucking into a huge meal. You will find that adding human subjects presents a whole new challenge in food photo photography.

You can capture every aspect of human interaction with food in a photo. Photograph someone setting a table, mixing dough, or filling a sandwich. There is no rule that says a food photo has to look perfect. Let your creativity take over while you learn to judge which parts of a scene are the most important—it's not as hard as you might think.

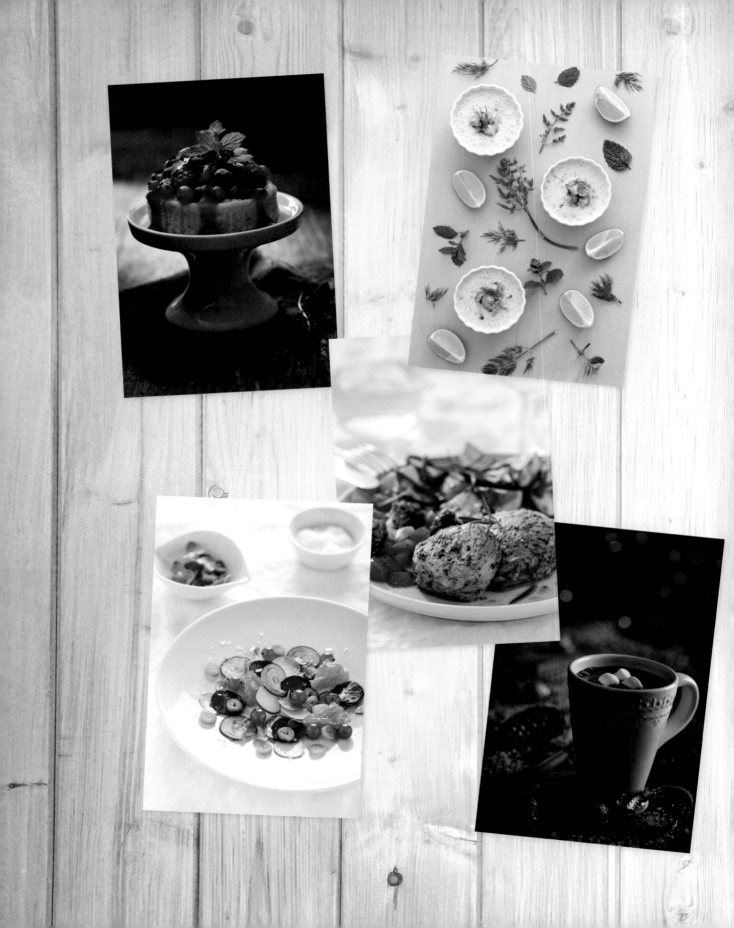

CHAPTER 6

Five Food Photography Projects

If you have read the previous chapters carefully, you will now be able to create appealing, well-composed, and meaningful food photos. You know which camera settings to adjust, how to capture the right mood, and how to use light and various props to underscore your intentions. When someone sees your photos, they can immediately imagine how the food tastes, and getting people's mouths watering is what great food photography is all about.

This chapter lets you look over my shoulder while I apply everything we have learned so far to real-world food photo projects.

Salads

Salads are not only healthy, but they also look great and are quite decorative. They are fresh, crunchy, colorful, and cry out "nutritious!"

Whether you are preparing a vegetable, fruit, or green salad, make sure that all of your ingredients are as fresh as possible. There is nothing less appetizing than wilted or moldy-looking food, and even slight signs of staleness can discourage a viewer from trying out a recipe. After all, your photos are designed to work up an appetite.

Cucumbers, tomatoes, and bell peppers stay fresh for a day or two, whereas berries and mushrooms quickly look tired and need to be photographed immediately. Plan your shoot carefully and always keep an eye on the shelf life of your ingredients. If you don't, you will simply end up frustrated. Always use the very best food, even if it takes longer and costs more.

Radish and Beetroot Salad with Shallots: You Can't Get Much More Tricky Than This

Preparation

As I began planning this shot, it quickly became clear that I needed a bright, clean look, so this project includes some extra tips on using flash.

I started with a deli salad in mind, but decided that a light, summery salad better embodied the idea of freshness I was after. There are many ways to prepare a shot like this. My online research turned up a number of suitable approaches, and a backlit shot was the one that inspired me most. Backlight provides strong contrast and is often the best option for salads. You can also adjust the degree of contrast by raising or lowering the camera—in this case, the effect ended up quite mellow.

The salad itself is the eye-catcher here, and I wanted to make sure that nothing competes with it for the viewer's attention, which is why I used exclusively white props.

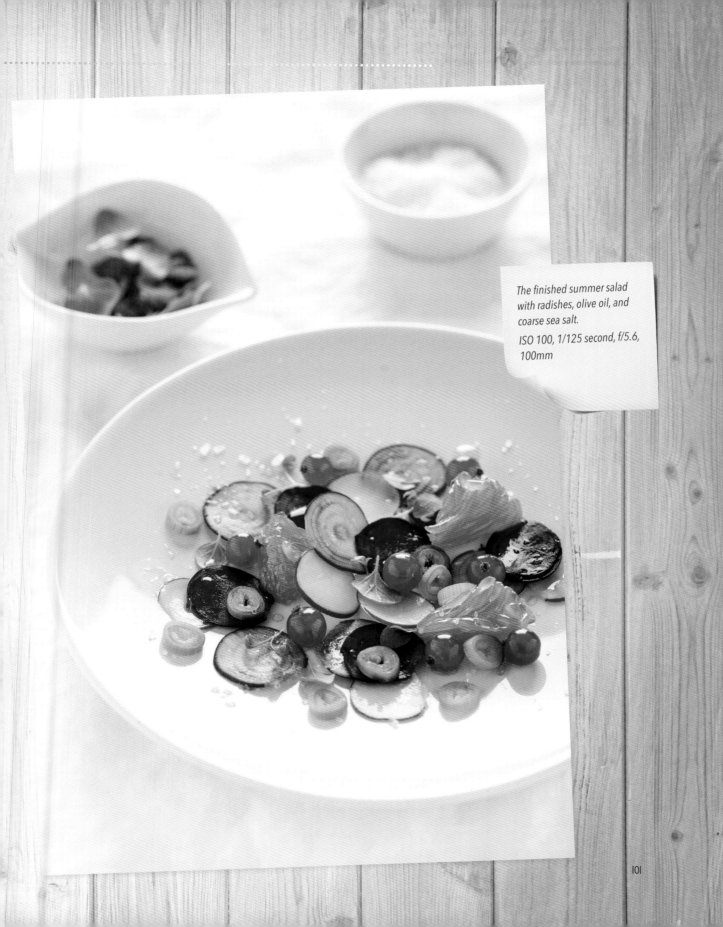

The finished summer salad with radishes, olive oil, and coarse sea salt.

ISO 100, 1/125 second, f/5.6, 100mm

The Shoot

I began by setting up the flash behind the subject and placing a piece of finely textured cloth on my table. Remember, cloth doesn't have to be completely smooth and sometimes a wrinkle or two adds texture to the overall composition. To prevent hard shadows at the edges of the plate, I positioned Styrofoam fill reflectors on the left and right. See page 105 for an overview of the set and the results of shooting with and without the fill reflectors. In both cases, the camera was positioned directly opposite the flash.

I then positioned my props. I used white dinnerware because the salad already included complementary colors that I wanted to use as the main eye-catcher. I used a green napkin and red pepper as dummies to mirror the colors of the real subject.

As you can see in the sample shots on the next page, the studio flash produced a significant highlight on the plate. To start with, I left this as it was to see how it worked in conjunction with the salad. I then moved the various props around until I came up with a setup I liked. The light was fine with a flash power setting of 3.0 that I set by feel alone. However, I knew that I wouldn't be capturing the final shot at my test aperture of f/8, so I also knew that I would have to reduce flash power for the final shot.

I set up the studio flash and softbox behind the subject to provide backlight. The fill reflectors on the right and left brighten the shot from the front and reduce the shadows.

An initial test shot with dummy subjects. At this stage, I ignored the highlight on the plate.

ISO 100, 1/125 second, f/8, 100mm

This shot shows the result of removing the fill reflectors. The shadows are much darker.

In these three shots you can see that I moved the rear bowls around looking for a balanced composition.

I marked the position of the plate with building blocks while I replaced the dummies with the real salad.

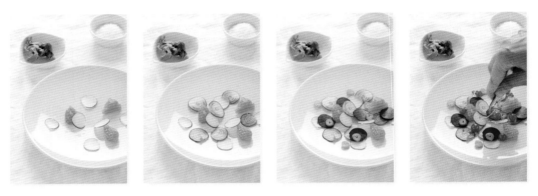

These shots show how I successively built up the subject using the tweezers from my styling kit.

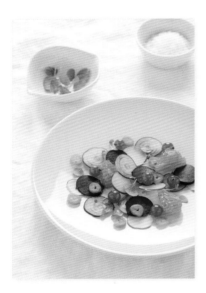

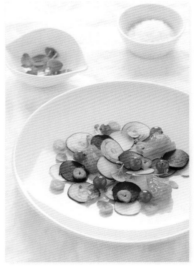

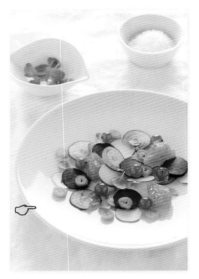

In this shot, I added fresh herbs to the bowl on the left.

Here, I lowered the camera to squeeze more of the subject into the frame.

Lowering the flash head shifted the reflection in the plate forward.

Once I was happy with the position of the props, I started setting up the real subject. I marked the position of the plate using building blocks before I took it away to remove the dummies.

I then began to build the fresh salad. This was really tricky and involved a lot of careful work with the tweezers from my styling kit. This job would have been impossible using my fingers alone. The trick when arranging a salad like this is to spread the ingredients evenly so that there are no clumps or gaps, which is easier said than done.

Once I was satisfied with the way the salad was set up, I placed some fresh herbs in the bowl on the left.

I was nearly ready to begin shooting, but still wasn't completely happy with the framing. I lowered the camera a little to center the subject and squeeze more of it into the frame. This provided a view similar to that of someone sitting down at a table to eat.

I shifted the two bowls to suit the new framing. The highlight on the plate was still slightly distracting, so I lowered the flash head a little to shift the highlight forward. The difference between the two versions is quite clear.

The rear portion of the scene was still a little too bright, so I placed a black cardstock flag beneath the flash to balance things out.

Left: A piece of black cardstock placed in front of the flash darkened the rear portion of the set and emphasized the texture in the tablecloth.

Right: The result of adding the black cardstock flag.
ISO 100, 1/125 second, f/8, 100mm

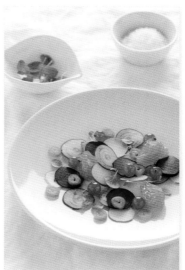

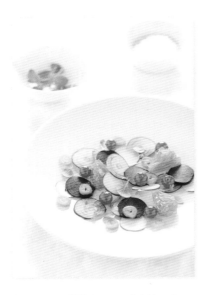

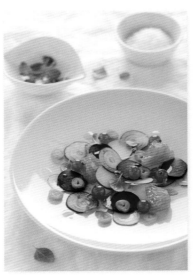

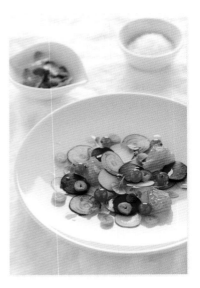

An aperture of f/5.6 was too bright, so I reduced the flash power to compensate.
ISO 100, 1/125 second, f/5.6, 100mm

I placed a few extra herbs on the tablecloth and added olive oil and sea salt to the salad. In the end, I decided not to use the extra herbs after all.

Instead, I added more herbs to the bowl at the rear.

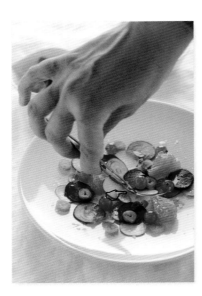

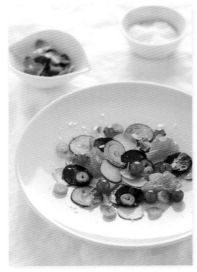

I again used tweezers to adjust the position of a slice of radish.

The finished photo of a summery salad.
ISO 100, 1/125 second, f/5.6, 100mm

I set the aperture to f/5.6 and took a test shot. This turned out much too bright, so I dialed the flash power down from 3 to 2. Positioning the flash farther away from the subject would have had the same effect, but I didn't have space to do this.

I focused on the salad and the rest of the frame remained slightly blurred. So far, I was satisfied with the depth of field in the photo.

I added a few drops of olive oil before releasing the shutter. If you use oil this way, be sure to add it just before you shoot, otherwise the oil will run together and eventually disappear completely beneath the salad. I also spread some herbs on the tablecloth. However, this spoiled the clean lines of the composition, so I removed them before I began shooting. Instead, I added a few more herbs to the bowl at the rear, which gave it more presence.

As a finishing touch, I added some coarse-ground sea salt. Salt absorbs oil really quickly, so I had to work fast. I used my tweezers to reposition a slice of radish that looked wrong.

The Result

The before and after views show the results of the post-processing steps I performed in Lightroom. I lightened the shadows, increased contrast, and sharpened the image. Take a close look at the photo and consider what you might have done differently.

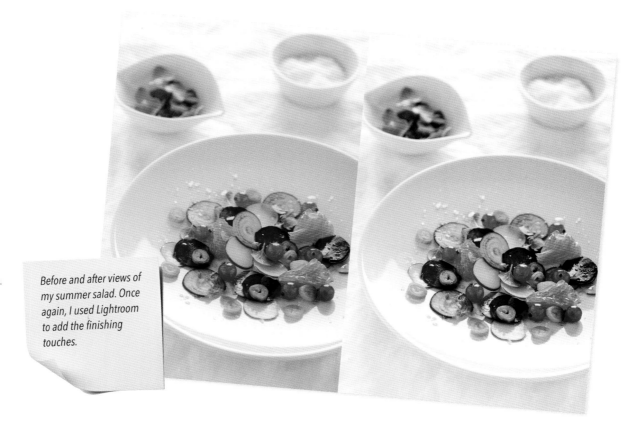

Before and after views of my summer salad. Once again, I used Lightroom to add the finishing touches.

Things to Think About

Problems and Solutions

- Lettuce wilts quickly, so you need to position it just before you are ready to shoot and be prepared to work quickly.

- To keep salads fresh and prevent them from drying out, spray them with oil or water.

- Salads often appear flat and one-dimensional, so make sure you arrange the ingredients in layers to give your salad depth.

Styling Options

- Try making individual portions of salad served in drinking glasses.

- Nut and seed salads look great presented in a serving spoon.

- Small plates and bowls can be just as attractive as larger ones and are often easier to work with on set.

- Even if you use a large plate, leave plenty of space around the subject. Less is often more and is easier on the viewer's eye.

Tips and Tricks

- Vary your cutting style to include julienned, spiraled, and sliced or chopped vegetables.

- Moisten cut vegetables with oil or water to keep them fresh and tasty-looking. If necessary, use a small brush to add oil in the required place.

- Serve thick dressings in a separate bowl or jug to prevent them flattening your salad.

- Add croutons, nuts, or fresh herbs to pep up a salad.

- Make sure that you cut your ingredients to provide small mouthfuls. Nobody likes to deal with whole salad leaves using a knife and fork.

- To keep work to a minimum, place a small inverted bowl in a large salad bowl and arrange your salad on top of it. This gives the subject depth and saves you from having to prepare a large serving.

- Use a pancake ring to shape deli salads and garnish them with herbs.

- Dilute thick dressings with water. This makes them look tastier and they are easier to pour over a salad.

- Make sure the individual vegetable and lettuce pieces are the same size. This is easier if you use a freshly sharpened knife or a grater.

Soups

Soups are extremely tricky to photograph. They are single-colored, have little recognizable texture, and the non-liquid ingredients usually sink straight to the bottom of the bowl. Furthermore, the surface creates reflections that can be interesting if you keep them to a minimum but can easily ruin a shot if they end up burned-out and detail-free.

The bland nature of soup makes it doubly important to decorate it attractively with croutons, herbs, and perhaps a dollop of cream. Soups provide a great opportunity for you to live out your styling fantasies.

Depending on whether you wish to photograph the soup alone or in the context of a more complex scene, you need to plan your shot accordingly. Perhaps you can show someone cradling a cup in their hands, or someone in the process of serving or garnishing the soup. There really are no limits.

Cold Cucumber Soup with Lime, Mint, and Dill:
A Real Framing Challenge

Preparation

There was a heat wave while I was working on this chapter, so this cold cucumber soup was the ideal recipe at the time. Soup doesn't always have to be hot. This Turkish soup isn't particularly photogenic itself, so I decided to garnish it with dill and croutons. There are countless variations to this kind of recipe, but this version also mentioned lime, which makes a perfect additional prop. I prefer to shoot using small bowls and plates, but just one small bowl didn't fill the frame, so I decided to use three backlit bowls captured from above with appropriately small bits of herbs and wedges of lime in between. The result of my efforts is reproduced on the opposite page.

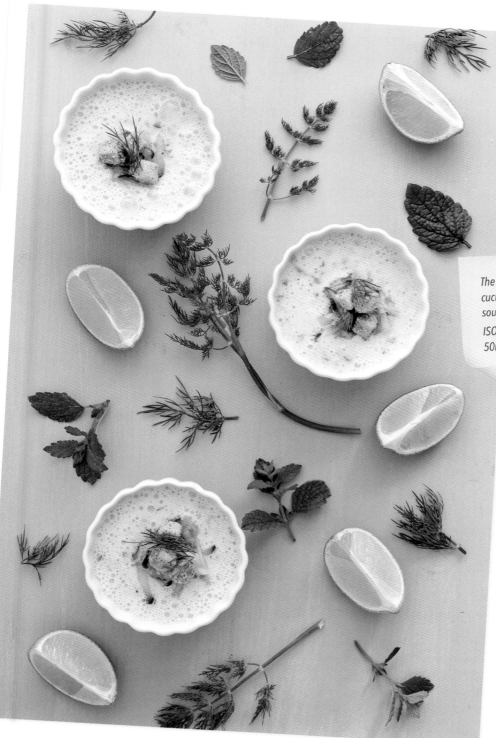

The finished shot of my cucumber, lime, and dill soup.
ISO 100, 1 second, f/8, 50mm

I set up a low table and a blue-painted board by my window.

I strategically placed three bowls on the board.

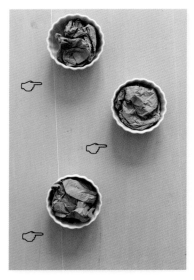

The bowls with their dummy contents produced too much shadow.

Adding a diffuser reduced the shadow effect. I stabilized the diffuser using spring clamps from a hardware store.

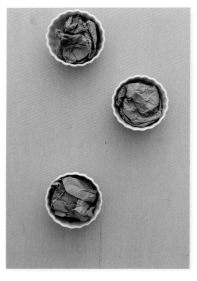

The diffuser almost completely eliminated the shadows.

I arranged the bowls to create a balanced composition. The rule-of-thirds lines shown here make an ideal reference.

ISO 100, 0.6 second, f/8, 50mm

The Shoot

As previously mentioned, I decided to shoot from a bird's-eye view. To use my beloved 100mm lens I would have had to get up too high, so I used my 50mm lens and a low table instead. I set up the scene in daylight and placed the camera opposite the light source to achieve the backlit effect I wanted.

I used a homemade blue-painted board for the background, which provided a color that was analogous to the subject. I used three bowls to create a graphically balanced look—remember, an odd number of elements is better than an even number. The three bowls also form a pleasing line for the viewer's eye to follow. To start, I placed the bowls randomly to get an idea of how the light worked.

I then filled the bowls with green napkin dummies while I worked on my setup. As expected, my initial test shot showed obvious shadows that I definitely didn't want in the final photo. To reduce the shadow effect and create soft, even lighting, I placed a diffuser between the window and the subject and fixed it in place with spring clamps from a hardware store.

The diffuser improved things a lot and helped produce the summery feel I was looking for. Once the light was set up, I began arranging the bowls. It is always more difficult to create a pleasing composition in shots captured from above. This isn't my favorite view, but it is still worth taking the trouble to get it right. I used the lines provided by the rule of thirds (see page 64) as a reference and began by placing the bowls at the intersections.

After a few attempts, I ended up using a slight variation with the uppermost bowl no longer positioned at the intersection but far enough away from the edge of the frame for the composition to remain balanced. With this type of shot, you don't have to glue your props in place, so you can always change their positions while you shoot. Experimenting with different setups is an important part of developing a feel for a balanced composition.

 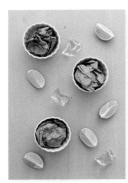

I began by experimenting with different positions for my props.

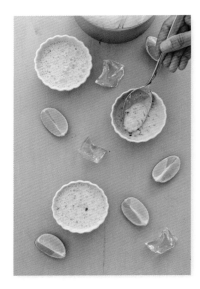 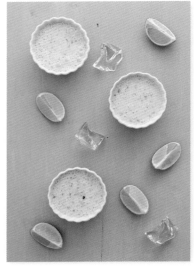 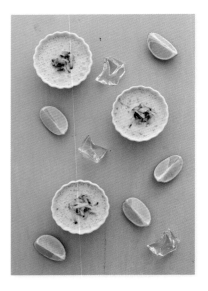

I filled the bowls using a spoon because a ladle would have been too large.

The filled bowls and the props.

Grated cucumber adds texture and emphasizes the main ingredient.

ISO 100, 1 second, f/8, 50mm

I used mint, dill, limes, croutons, and ice cubes as garnish. The ice cubes were a spontaneous idea and I used them to underscore the cool-warm contrast in the photo. Because herbs wilt quickly, I began by experimenting with the limes and my plastic ice cubes. I wasn't really sure at this stage how I wanted the final photo to look, so it was simply a case of trial and error.

Once I was happy with my setup, I used a spoon to carefully fill the bowls. They were too small to fill using a ladle. I then arranged some grated cucumber on the surface of the soup to emphasize the main ingredient—without this element, I don't think the soup would have been recognizable as cucumber soup at all. The soup itself came fresh from the blender and was thick enough to allow the grated cucumber to float on the surface.

I then used the tweezers from my styling kit to carefully add a few croutons and some dill to the center of each bowl. Once the bowls were finished, I experimented with the number and position of the props in between.

I styled the soup with croutons and dill. Once again, my tweezers saved the day when it came to doing the finicky stuff.

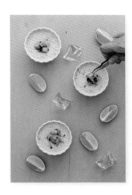 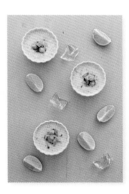 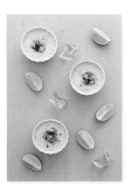

I added dill and sprigs of mint to the rest of the set.

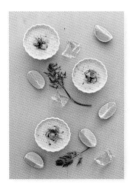

When viewed on my computer, the ice cubes looked too chunky, so I decided to leave them out. I changed a couple more details, then continued to shoot using an aperture setting of f/8 to keep the subject and the background nice and sharp.

To check out a different effect, I also captured a shot with a fill reflector placed in front of the set. However, the result was too flat for my taste—what do you think? I decided not to use the reflector, and the result has more depth and a nice light-to-dark gradient from top to bottom.

In post-processing, I cropped the photo to get rid of the excess empty space on the left. The final photo turned out quite different from my initial idea, but I really like the result. What do you think? Is it nicely balanced or too busy?

In the end, I decided against using ice cubes.

I filled the gaps left by the ice cubes with other props.

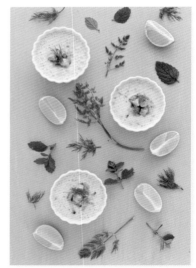

This version, shot with a reflector positioned in front of the subject, is flat and lacks contrast.

ISO 100, 1 second, f/8, 50mm

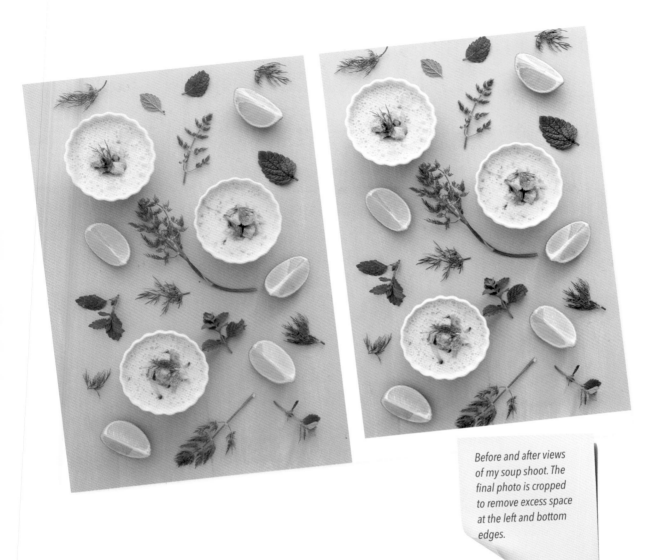

Before and after views of my soup shoot. The final photo is cropped to remove excess space at the left and bottom edges.

The Results

Here you can see the final image, shot with a long exposure time to keep the overall mood bright and summery.

Things to Think About

Problems and Solutions

• Vegetables and other ingredients tend to sink to the bottom of a soup. The trick detailed on page 194 will help you avoid this issue.

• Alter your shooting angle to eliminate reflections on the surface of a soup, or use a diffuser to reduce their intensity.

• Vegetables lose their color quickly, so prepare carefully and work fast when photographing vegetable soup.

• Overcooked vegetables lose their luster, so it is better to use slightly undercooked ingredients for your photos.

Styling Options

• Serve soup in cups instead of bowls.

• Traditional soup plates look great in a photo.

• Soup bowls on plates create a balanced look.

• Cold soup served in glasses is a nice variation from traditional soup photos.

• Food served in an open jar with a spoon immediately gets the viewer's mouth watering.

• Soup served in its cooking pot looks good too.

• Try photographing a full soup ladle from close up.

• I like to photograph soup served in a tin can. This approach is on trend and produces unusual-looking results.

• For an unconventional look, try filling bottles with soup.

If a shoot begins to move in an unexpected direction, run with it. You will often find that spontaneous ideas turn out to be just as good as the shot you originally planned.

Tips and Tricks

- If you are filling bottles, glasses, or any narrow vessel with soup, use an eyedropper or a small jug to prevent unwanted splashes and drips.

- Soups always benefit visually from a finishing touch such as croutons, watercress, or a dollop of cream.

- Slices of french bread are a great soup accessory.

- Always fill soup dishes after they have been positioned and are ready to shoot. Liquids slop around and leave marks that you then have to remove.

- Try photographing fresh, hot soup in front of a dark background. This enables you to capture the steam along with the soup itself.

- If you add cream or froth to a soup, use a small spoon to twirl it into attractive patterns.

- Using chopped raw ingredients as props adds color to a soup shot and helps the viewer identify the main subject.

Main Dishes

Main dishes are a real photographic challenge. Not only do you have to arrange multiple elements, but you also have to ensure that everything is ready simultaneously. Then you have to arrange your meat or fish, potatoes or rice, side dishes, and sauces so that they look fresh and attractive, all while concentrating on a host of details and avoiding an overloaded look. And you'll probably be hungry by the time you get to shoot too! Try to plan ahead so that you can work calmly and quickly when its time to add the finishing touches and press the shutter button.

Here, too, you need to buy really fresh ingredients. Meat should be pink, not gray, and vegetables need to be fresh and crisp. New potatoes or other small varieties are easier to arrange decoratively.

Pork Fillet with Rosemary Potatoes and Steamed Vegetables: Animals Can Be So Stubborn!

Preparation

I don't particularly like eating or photographing meat, but there is no end to my dedication when it comes to keeping my readers happy! Meat doesn't always look appetizing and can be tricky to photograph effectively. Fortunately, I usually get to decide what I shoot.

For this shot, I decided to use fillets rather than bony cuts, and pork fillets provided the small slices I was looking for. I had to do some research on what goes well with pork and chose to use rosemary potatoes with broccoli and bell peppers for added complementary color.

I wanted to set up a classic table scene with drinks and flatware, and the main dish in the spotlight. Lighting-wise, I went for soft, diffuse light from behind.

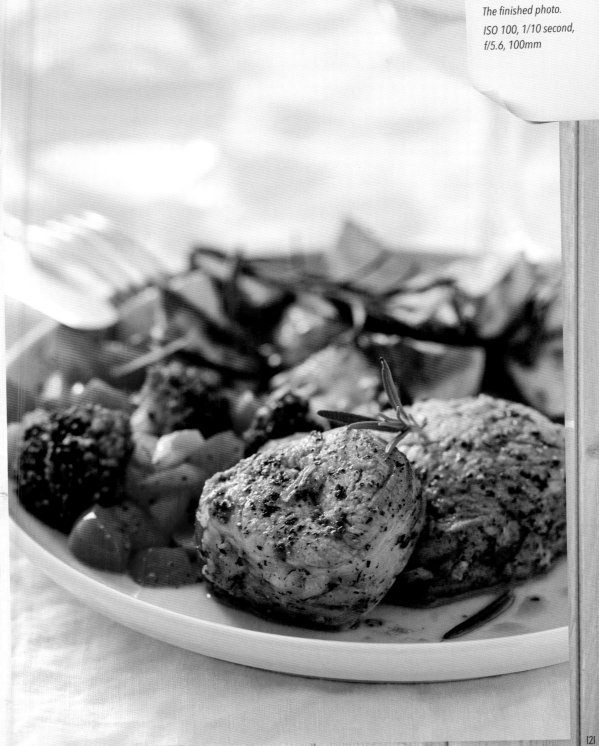

The finished photo.
ISO 100, 1/10 second,
f/5.6, 100mm

The Shoot

I set up my table so that the light from the window hit the subject diagonally from behind, and I added a diffuser to prevent obvious shadows. I positioned the camera directly in front of the set. I placed a fill reflector to the right to prevent the right-hand side from looking too dark. Check out the water bottle taped to the reflector—this is a great way to keep a sheet of Styrofoam in place.

To check my lighting, I used a plate with brown, green, and white dummies in place of the meat, vegetables, and potatoes. I shifted the camera to the left to combat the highlights on the edge of the plate.

I then began to experiment with the positions of the other props, which included a wine glass and decanter in the background.

Setting up glass objects in front of a white background can be quite tricky, so I poured some wine to help me get the positions right. Wine and juices don't lose their fresh look as quickly as beer (see page 190) and shakes, so you can usually pour these at the start of a shoot.

The table is set up diagonally in front of the window with a diffuser behind the subject.

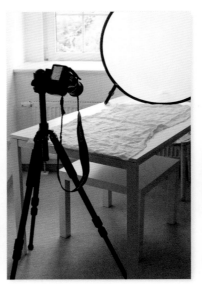

The camera is positioned directly in front of the subject.

A reflector at front right softens the shadows.

Left: My initial setup displayed obvious highlights.
ISO 100, 1/6 second, f/8, 100mm

Right: I moved the plate to the other side of the table to combat the highlights.
ISO 100, 1/6 second, f/8, 100mm

I added the background props and experimented with different positions.

I tried adding flatware but decided against it in the end.

Below: I began by arranging the potato wedges, followed by the vegetables (arranged with a spoon), and finally the meat.

Left: I used a Q-tip to remove some specks of oil from the edge of the plate.

Right: I rearranged the potatoes once more.

Flatware is difficult to arrange effectively in closeups like this. In the first shot, it wasn't conspicuous enough, and in the second it was too dominant.

I shelved the flatware idea and started arranging the potatoes instead. Always start with potatoes or other firm vegetables that won't collapse or lose their shape while you work. I then used a spoon to add the vegetables. Finally, I added the meat, placing it in the classic six o'clock position (check the position of the meat on the plate next time you eat out). I tried adding a third piece of meat, but this made the plate look too full. My test left behind some oil smears that I had to carefully remove using a Q-tip. I also rearranged the potatoes to give them more height and substance.

To get the framing right, I moved the camera upward and slightly closer to the set, once again positioning the subject according to the lines produced by the rule of thirds. The meat ended up at the lower intersection of the imaginary lines.

All this took time, so I had to brush some oil onto the meat to reinvigorate its moist look. Meat tends to dry out quickly, so you have to work fast to get this type of shot in the bag while everything still looks fresh.

I raised the camera slightly and moved it closer to the subject, and positioned the meat at the intersection of the lines formed by the rule of thirds.

I brushed oil onto the meat to keep it looking fresh.

I removed one of the broccoli florets to balance the composition, leaving just three on the plate. I also added some rosemary to the food and the background.

I then repositioned the flatware—it had to fit in somewhere—and changed the aperture from f/8 to f/6.3 to increase the background blur effect. In the end, I opened it up one more stop to f/5.6, my favorite aperture.

The sprig of rosemary in the background was too prominent, so I replaced it with just a couple of leaves. I still wasn't happy with the effect, so I removed the rosemary altogether. Food photography often involves a lot of experimenting until a shot looks right.

I also adjusted the position of the light-colored potato wedge so it wouldn't draw attention away from the main subject. Compare the two photos at the bottom of page 127 to see the difference this makes.

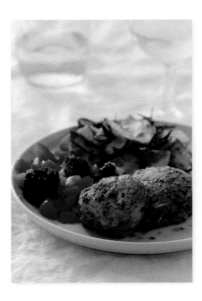
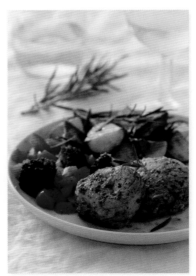

Left: I removed one of the broccoli florets to balance the composition.

Right: I added rosemary to the food and the background.

Left: Another attempt at adding flatware.
ISO 100, 1/6 second, f/8, 100mm

Right: I opened up the aperture to f/5.6 to brighten and emphasize the meat. I also replaced the sprig of rosemary in the background with individual leaves.
ISO 100, 1/8 second, f/5.6, 100mm

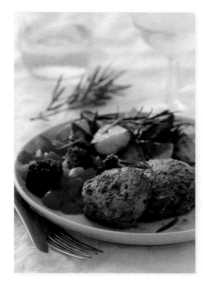
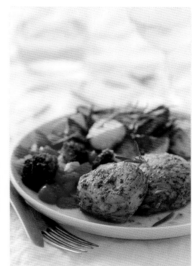

Left: I removed the rosemary and rotated one of the potato wedges to make it brighter and more eye-catching.

Right: In the end, I preferred the version without the rotated potato.

Left: Moving the fill reflector forward lightened the meat and reduced the shadow effect.

ISO 100, 1/8 second, f/5.6, 100mm

Right: The final position for the flatware at the rear edge of the plate.

I shifted the fill reflector forward to soften the shadows at the front and lighten the meat. I moved the flatware to the rear edge of the plate to keep it in the frame but make it less obvious. As you can see, I left a couple of drops of oil on the plate to preserve the authentic look of the shot.

The Result

After a fairly lengthy setup process, the final result turned out very good indeed.

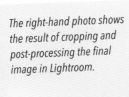

The right-hand photo shows the result of cropping and post-processing the final image in Lightroom.

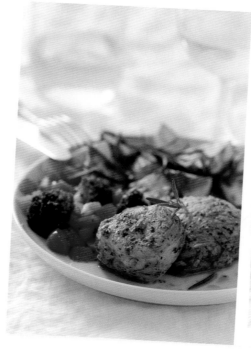

Things to Think About

Problems and Solutions

- Main dishes are comprised of multiple elements and a plate can easily look too full. Try to look at your setup through the eyes of a guest at a restaurant—is it both visually attractive and appetizing?

- Sauces form a skin and quickly take on a matte look. Always make pouring your sauce the final step before you take a photo.

- Meat loses its moist look when cut, so you have to work quickly to keep your dish looking fresh.

- Vegetables also dry out quickly, so it pays to plan your shoot carefully and always keep some oil and a brush on hand to add moisture.

- Use dishes you have seen in restaurants as a guide when arranging the individual elements in a main dish. The star of the show usually faces the patron, although this is not a hard-and-fast rule. For example, meat also looks great served on a bed of mashed potatoes.

Styling Options

- Raw slate makes a classy alternative to regular plates.

- Use wooden serving boards instead of plates for rustic-style dishes.

- Try photographing your food in the pan used to cook it.

- Pots can also be used as part of a food photo composition.

- Rice-based dishes look great served in bowls instead of on plates.

Tips and Tricks

- Don't fill the plate too much—smaller portions are more appetizing.

- Distribute vegetables and sides evenly on the plate.

- Always add the sauce last before you shoot.

- Arrange the firmer elements of your composition first, followed by the softer ones.

- Thicken sauces and position them carefully using a spoon. This gives you much more control over the way they look and flow.

- Use a piping bag to serve mashed potatoes and parsnips.

- Use a cup to form rice and arrange the other elements of the dish around the central rice dome.

- Whisk sauces to add froth before serving.

- Herbs, nuts, and edible flowers add variety to photos of main dishes.

- Always place meat or fish at six o'clock.

- Undercook vegetables to keep them looking colorful and fresh.

- Slices of meat often look better than a single cut.

- Don't cook meat for too long. This prevents it from drying out and looking gray and unappetizing.

- Leave the rim of the plate empty.

- Use only the most attractive cuts of meat and vegetables for your photo and make sure the tastiest-looking side of the plate faces the camera.

Desserts

Desserts are my favorite subjects, and after I have captured them in delicious-looking photos, I get to eat them! Whether you shoot soft, pastel-colored dessert photos or darker, earthy-looking ones is up to you. You can style desserts to your heart's content—they always look good. That doesn't mean you can't create subtle dessert shots too. It's up to you how you present your food.

Whether it's a cake, homemade cookies, trifle, ice cream, mousse, or whatever, a dessert needs to be presented in a way that does justice to the care you took preparing it. That is, of course, if you can manage to resist eating it before you start shooting. This section demonstrates just one of a thousand ways to photograph desserts.

Curd Tartlet with Berries and Fruit Sauce: Subtlety at Work

Preparation

Desserts come in all shapes and sizes, from sugary-sweet to tangy and tart, creamy, layered, baked, and so on. This section demonstrates how I approach a dessert shoot and capture a particular lighting mood. The darker a photo, the greater the role played by the mood of the lighting. I had already decided against photographing cookies or muffins, but I wanted to shoot some kind of pastry decorated with berries. Berries are ideal for pepping up desserts, especially if you mix contrasting colors. For this shot, I decided to top off my tartlet with a berry-based sauce to make it look really irresistible. Drops of sauce running off a dessert give it a highly authentic look.

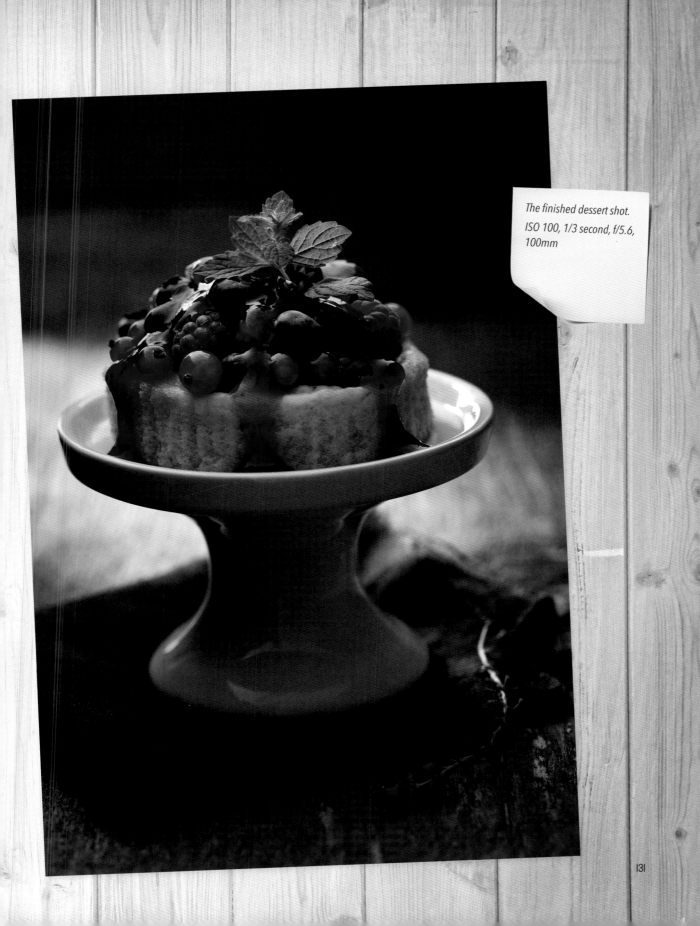

The finished dessert shot.
ISO 100, 1/3 second, f/5.6,
100mm

I positioned the table diagonally in front of the window. Here you can see my baseboard and the wooden crate I used as a background.

I added flags on both sides.

I closed the blinds on the right-hand window to reduce the intensity of the main light.

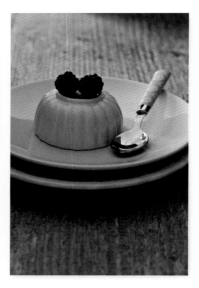

This shot clearly shows the contrast between light and shade on the set.

I added my props and a dummy.

For my first test shot, I set up the camera relatively close to the subject.

The Shoot

I wanted the main light to come diagonally from the rear, so I set up my table at an angle and got out my favorite beat-up wooden background. To complete the effect, I placed an old wooden crate behind the subject and lined up the camera at eye level.

I used flags on both sides of the set, although the left-hand one was smaller, allowing plenty of main light to reach the subject. I made this flag myself from Styrofoam. See chapter 9 for more on homemade studio accessories.

I closed the blinds on the window on the right to reduce the overall intensity of the light and enhance the interplay of light and shade. You can hang a bed sheet in front of a window to achieve the same effect.

I then set up my props and used an inverted bowl with berries on top as a dummy dessert.

I altered the camera angle to a little above eye level and moved in closer to the subject but found that this opened up a gap in the background, so I moved the wooden crate to the left to compensate.

Left: I moved the wooden crate to close the gap in the background.

Right: The main light is much more controlled.
ISO 100, 1/2 second, f/8, 100mm

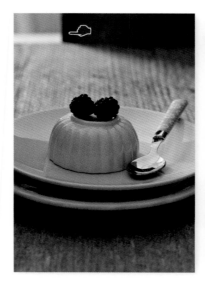
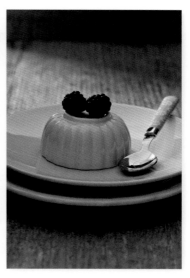

The plate I used to set up the shot was too big, so I tried using a mini cake stand instead. See chapter 9 for tips on how to make your own.

I placed a small piece of blue linen under the plate to match the color of the blueberries and increase overall contrast. If you've tried using fabric or paper accessories in your food photos, you will already know how much effort it can be to get them looking right. This particular prop required several modifcations until I found the right look—not too smooth but not too crumpled.

Once the plate was set up, I put the tartlet in place, with its best side to the front, and began to add the berries. I added the blueberries and blackberries first, and then the more delicate raspberries and red currants. Once again, I used the tweezers from my styling kit to do the finicky stuff. Getting subjects like this to look right often requires a lot of effort.

Once everything was looking good, I switched the aperture from f/8 to f/4.5 to make sure that the background remained blurred. This turned out to be too much of a good thing and blurred the berries too (see the two photos at the foot of the opposite page), so I switched to f/5.6 for the final shot. This kept the background blurred but shifted the berries into focus.

 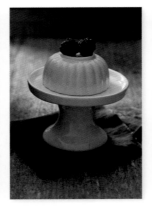

I swapped the plate for a cake stand.

My first few attempts at adding a piece of fabric.

Left: The naked tartlet on the cake stand.

Right: I used tweezers to build up an attractive-looking mound of berries.
ISO 100, 1/2 second, f/8, 100mm

Left: An aperture of f/4.5 made the background nice and blurry but the berries weren't sharp enough.
ISO 100, 1/6 second, f/4.5, 100mm

Right: Closing the aperture down to f/5.6 kept the background blurred and also enabled me to keep the entire subject in focus.
ISO 100, 1/3 second, f/5.6, 100mm

Left: I moved the camera closer and aligned the subject with the upper horizontal line in the rule-of-thirds grid.

Right: I added a flag on the left to attenuate the main light.

Left: I used a spoon to add sauce.

Right: Drops of sauce running down onto the plate and a sprig of mint made the dessert look even tastier.

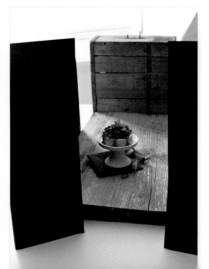

Left: Adding a second flag on the right balanced the light, and a red currant twig loosened up the overall composition.

Right: An overview of the flags I used.

The next step was to move the camera closer to fill more of the frame and include more background in the shot. I framed the shot so that the berries were aligned with the upper horizontal line of the rule-of-thirds grid.

I placed a flag to the left of the subject to reduce the intensity of the main light and increase overall contrast.

At this stage, I no longer liked the appearance of the berries, so I added a few more to get the look I wanted. Once the berries were arranged I used a spoon to add the sauce. Thin sauces can also be applied with a syringe. Be careful not to add too much sauce, otherwise your dessert will look drowned and unappetizing. However, a few drops of sauce running down the side of a dessert make it look even better. For my final styling touches, I placed a sprig of mint on top and a red currant twig beside the cake stand, mirroring the berries in the dessert.

I still wasn't happy with the lighting, so I added a second flag on the right. I kept the exposure time short to preserve the dark, rustic look.

The Result

I once again used Lightroom to get the best out of my image. In this case, I slightly darkened the right-hand side of the frame and lightened the berries. I also sharpened the entire image and dialed up the contrast. Which version do you prefer—before or after?

Before and after shots with the post-processed version on the right.

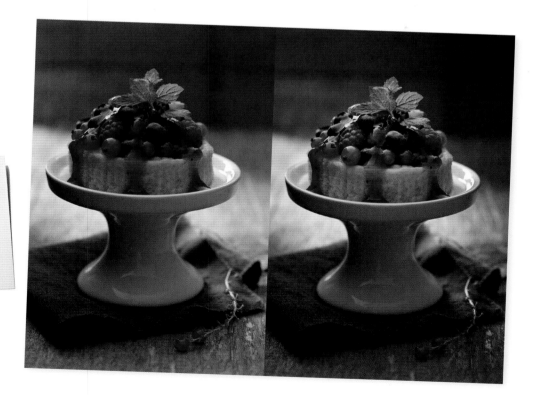

Things to Think About

Problems and Solutions

* Desserts tend to melt quickly, so cool them in the fridge before a shoot.

* When shooting delicate dishes such as soufflés, you have to prepare well and work quickly to capture them looking their best.

Styling Options

* Layered desserts look best in glass dishes.

* Try serving desserts in matching colored dishes.

* Serve a dessert in the baking tray you used to make it.

* Serve cookies or candies in cellophane bags.

* Pastries look great on a cake stand.

Tips and Tricks

* Present desserts in a sauce "lake" (often called a coulis).

* Even ribbons work as garnish for desserts.

* Add soft elements such as whipped cream just before you are ready to shoot.

* Mint leaves, grated chocolate, and slices of fresh fruit make great finishing touches.

* Backlight is ideal for photographing desserts served in glass dishes.

Drinks

Drinks present a real challenge, although this section is less about creating an advertising-style shot of a glass of beer and more about making things like cocktails, smoothies, and shakes look tasty. There is one unbreakable rule when it comes to photographing drinks: never shoot drinks on a tilt. If you see a photo of a tilted drink, you will immediately want to set it straight. Aesthetic issues plague drink photography. It is all too easy to leave a fingerprint on a freshly polished glass; fizzy drinks produce ugly residue on the rim of a glass in seconds; you wait just a second too long before releasing the shutter and the froth on your latte collapses in front of your eyes. There are all sorts of things that can go wrong, so once again, careful planning is key. If you can get someone to help you on a shoot, you are sure to have an easier time making enticing photos of yummy drinks.

Drinking Chocolate in Winter: Experimenting with Bokeh

Preparation

I love kitschy, cozy-looking scenes, so when I was considering which subject to choose for this section, a warm drink was a natural choice. What better than hot chocolate to fit this particular bill? The concept was to create a cozy Christmas scene rather than a light, summery shot, which simply wouldn't fit in with hot chocolate and snugness. I am convinced that bokeh effects (those fuzzy spots of light) are an integral part of a Christmassy mood.

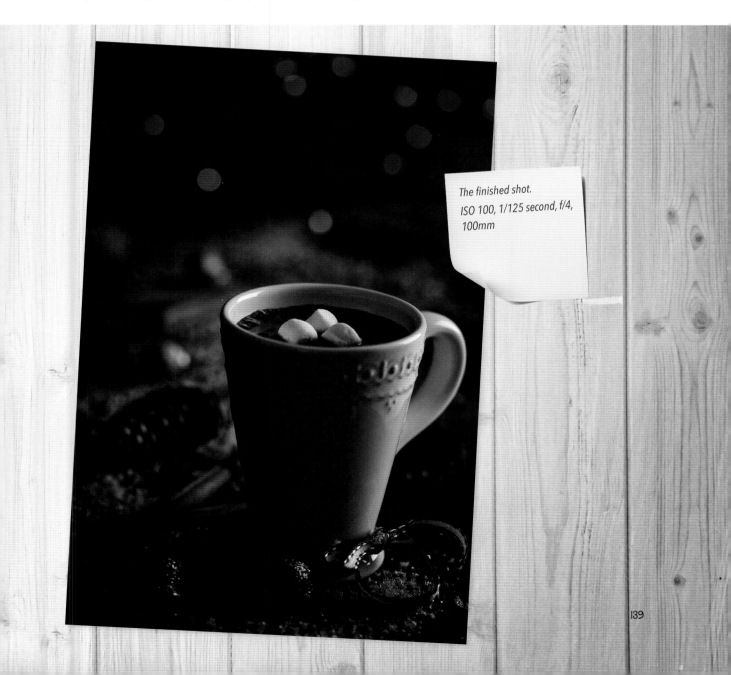

The finished shot.
ISO 100, 1/125 second, f/4,
100mm

The Shoot

To save space, I set up my table against the wall and placed a large reflector in front of the window to block some of the daylight shining through it. Of course, if you are shooting in the late afternoon or evening, you don't need the reflector. I used the same wooden base and background as I did for the dessert shoot in the previous section, added twinkle lights to the crate, and set up my studio flash to light only the rear portion of the set.

I added a flag on the left to provide a brightness gradient from left to right, which you can clearly see on the wooden board. The yellow color you can see in the flash is its modeling light—the flash itself didn't fire while I was shooting the overview photos.

I set up my props and positioned the camera at a right angle to the set to take some shots of a napkin dummy in a blue cup. I generally like pastel colors a lot, but blue—which is a wonderful color for shots of pastries and cakes—didn't suit this particular setup.

Further test shots using a brown cup produced a nice tone-on-tone effect but too little contrast. In the end, I went for a white cup and set up a Styrofoam fill reflector to provide more light on the left. The shots on the following pages show how it all fit together.

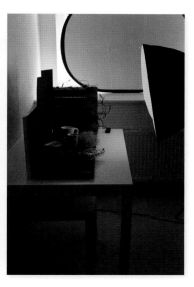

I used my favorite weathered board as a base and a wooden box as a background. The studio flash is positioned behind the set.

I hung a set of twinkle lights over the box and added two flags on the left to keep this side of the shot nice and dark.

I added the props to the set.

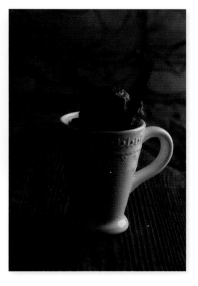

A blue cup didn't suit the mood.

A brown cup wasn't the right option either.

A white cup suited the overall look but required a fill reflector on the left.

The reflector lightened the left-hand side of the cup.
ISO 100, 1/125 second, f/8, 100mm

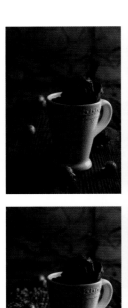 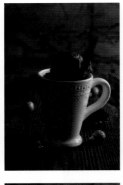 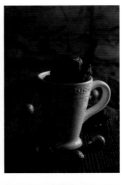

I added some Christmassy accessories to the set.

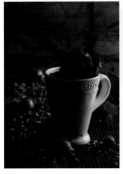 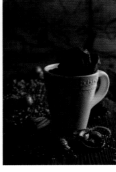 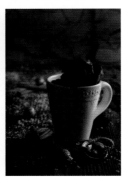

While I was adding some artificial snow, I noticed a highlight in the base of the cup that I covered with a piece of ribbon.

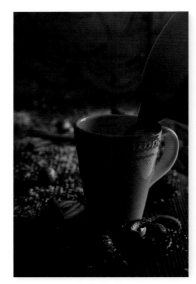

I used a bowl with a spout to fill the cup with hot chocolate.

Here, I changed the camera angle to provide a better view into the cup.

The new angle brought more of the background into the frame, so I rearranged the background props accordingly.
ISO 100, 1/125 second, f/8, 100mm

Styling a Christmas scene when it's 90 degrees outside can be tricky, and I had to take a lot of test shots to get this one right. I viewed the test shots either on my computer or in live view. The changes I made included rotating the cup to make the handle less prominent and adding artificial snow to the background. I also had to find a way to reduce the highlight at the base of the cup; a piece of ribbon did the trick.

I filled the cup very carefully, doing my best to avoid dripping hot chocolate on its rim, and then altered the camera position slightly to provide a clearer view into the cup. This also made more of the background props visible, so I had to rearrange those too.

I set an aperture of f/5.6 to keep the surface of the drink in focus and simultaneously produce a sweet bokeh effect in the twinkle lights. This relatively wide aperture made the overall scene too bright, so I dialed the power setting on my flash down to 1.3 to compensate.

Switching on the twinkle lights produced exactly the bokeh effect I was looking for, and I dropped the lights further into the frame to increase the number of bokeh blobs in the final image.

Left: Switching from f/8 to f/5.6 made the result too bright.
ISO 10, 1/125 second, f/5.6, 100mm

Right: I reduced the flash power to 1.3 to compensate for the wider aperture.
ISO 100, 1/125 second, f/5.6, 100mm

Left: The twinkle lights produced a nice bokeh effect in the background.

Right: I lowered the chain of twinkle lights to get more bokeh into the frame.

Left: Opening up the aperture blurred the wires and enlarged the bokeh blobs but made the overall image too bright.
ISO 100, 1/125 second, f/4, 100mm

Right: I reduced the flash power to 1.0, which darkened the image and made the bokeh more pronounced.

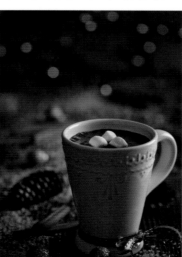

The marshmallows are a great eye-catcher. I styled them to coincide with the vertical line in the rule-of-thirds grid.
ISO 100, 1/125 second, f/4, 100mm

To eliminate the last vestiges of the twinkle light wires and to emphasize the bokeh effect a little more, I opened the aperture up even further to f/4. Once again, this made the shot too bright, so I reduced my flash power to 1.0 to balance things out. The wires disappeared into a mass of blur and the blobs became larger.

I topped off the hot chocolate with marshmallows to give the drink more texture and act as an eye-catcher. I used a fairly central position for the cup, although placing it closer to the edge of the frame would have produced an image with more tension.

The Result

During post-processing, I sharpened the image, increased the overall contrast, and added a subtle vignette before straightening it. I should have noticed that the cup wasn't straight during the shoot, but hey, nobody's perfect. Corrections like this are easy to master using the Lightroom Crop tool.

The far right-hand image was processed using a Lightroom preset. See page 174 for more details on how to do this.

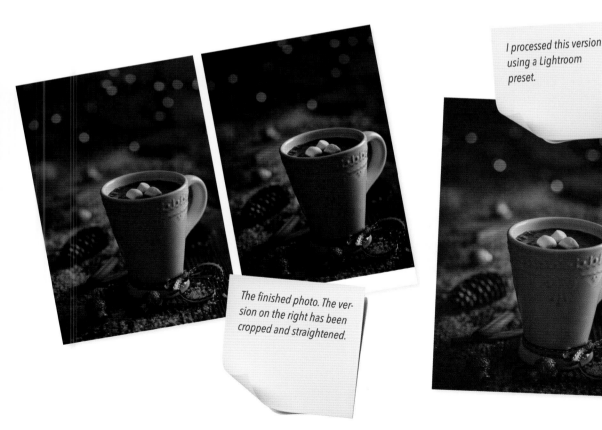

I processed this version using a Lightroom preset.

The finished photo. The version on the right has been cropped and straightened.

Things to Think About

Problems and Solutions

- To reduce or eliminate unwanted highlights and reflections, either adjust your shooting angle or use a diffuser.

- To prevent unwanted splashes and spray, use a decanter or spouted measuring cup to pour liquids.

- Fill glasses after they have been positioned on the set, otherwise the liquid will jog and splash when you move glasses and bowls around.

- To prevent condensation from spoiling a shot, wait for hot liquids to cool down before pouring them into the glass or bowl on set. You can create artificial condensation to emphasize the refreshing look of cold drinks using a mixture of water and glycerin and a plant sprayer.

Styling Options

- Serve hot drinks in cups.

- Serve shakes and smoothies in tall glasses.

- Decanters are a great option for all liquids.

- Small milk bottles are great for portioning liquids.

Tips and Tricks

- When photographing drinks, always keep a microfiber cleaning cloth handy for removing fingerprints and grease from glasses. If you can, wear cotton gloves for drink shoots.

- Use glycerin and water to create artificial condensation (see page 188).

- Steaming hot drinks look great in front of dark backgrounds.

- Don't fill glasses and cups too full.

- Pour drinks carefully to avoid splashes.

- Artificial ice cubes are a cheap and really effective prop.

- Make sure your horizon and/or the drink you are photographing is level.

- Consider adding a straw when photographing cocktails.

Summary

These projects clearly demonstrate how quickly a planned sequence of actions can change, and the point at which you position a fill reflector or diffuser will depend heavily on your own personal workflow. Even the most experienced photographers have to experiment sometimes, and you will often find that you need to rearrange the "final" positions of your props or swap a reflector for a flag. The most important thing is that the result looks irresistibly appetizing.

Develop Your Workflow

Developing your own workflow ensures that you can approach each shoot calmly. The following list details the steps involved in a shoot:

- Formulate a concept for the subject at hand.
- Write a list of the ingredients you need to buy.
- Reserve enough time for cooking, styling, and shooting.
- What mood are you looking to create? What is the message you want to communicate?
- Which props do you need and how do you want the finished composition to look?
- What type and direction of light suits your scenario? Make test shots to check your setup.
- Which angle of view best suits the dish you are working on?
- Begin by building up the set and making temporary camera settings.
- Prepare the food.
- Set up the food and perform the required styling steps.
- Shoot your images.
- Post-process your images.
- Save the results.

Common Mistakes in Food Photography

It is easy to make potentially avoidable mistakes when you find yourself in the middle of an intense shoot. The following are some things to watch out for:

- Pay close attention to every detail within the frame. There is nothing more annoying than discovering something that is impossible to retouch after a shoot.
- Avoid stress by staying organized.
- Removing unwanted crumbs and specks on set saves time-consuming post-processing later on.

- Always make sure you have plenty of time. Shooting in a hurry is frustrating and virtually guarantees substandard results.

- Organize your props before you prepare your food.

- Charge your camera batteries before every shoot. It is really frustrating if the camera dies right when everything is set up.

- Double-check focus, especially if you are not shooting tethered or using live view.

Improving Your Technique

Food photography can be very demanding, especially when you are just starting out. It takes time to develop your own style and technique, and you will need to practice a lot before you can create photos that communicate the look and feel you have in mind. The mood of the finished photo depends heavily on the aperture you use as well as the angle of view. The following is a list of tips that will help you get a feel for your work:

- Shoot every dish from a variety of angles.

- Rearranging the set during a shoot produces varied images and helps you practice your composition skills.

- Make sure you use the correct white balance setting.

- Let your photos tell a story.

- Build a trial set and test your lighting before you proceed.

- If a shoot simply isn't working, take a break and try again later.

- Plan your composition in advance.

- Consider the position of the main subject before you set everything up.

- Keep an eye on the colors and make sure they don't clash.

- Ask yourself whether your photos make the food look appetizing.

- Double check your camera settings before you shoot.

- Style your food on set and always keep some spare accessories handy.

- If you are not happy with your results, rearrange your set and try a different composition.

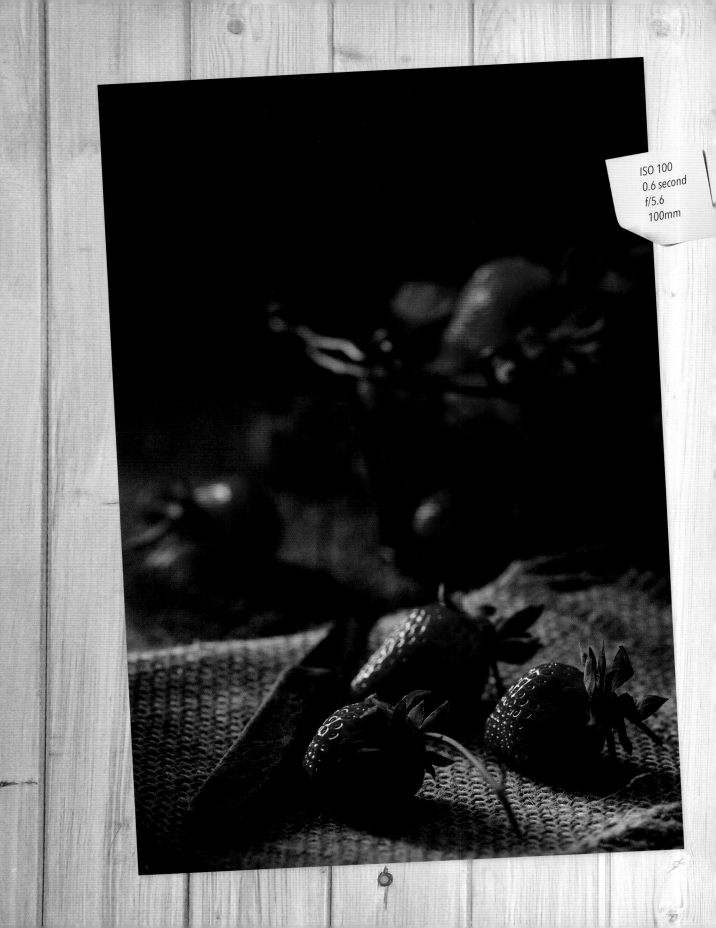

ISO 100
0.6 second
f/5.6
100mm

CHAPTER 7
Image Processing with Lightroom

Now that you have worked your way through all of the previous chapters, tried out all sorts of new ideas, played with your lighting, and probably cursed a little, you undoubtedly want to get the very best out of the photos you have captured and present them to other people.

Image processing takes place at the end of a shoot and requires just as much dedication and practice as preparing and photographing your food. Image processing can be a lot of fun—read on to find out how.

About Lightroom

Image-processing software is available in a range of prices from free to the cost of a good vacation. Free programs like GIMP and Paint.NET don't have as many sophisticated tools and features as Lightroom but are nevertheless fine for performing simple processing. Photoshop Elements is a kind of Photoshop "lite" that is cheaper and simpler to use than the full-featured version of Adobe's flagship application. It is up to you to try out the various packages and decide which price point and feature set suit you best.

I've used Lightroom right from the start and, due to my work, have since added Photoshop to my software portfolio. Lightroom doesn't cost the earth, offers sufficient features for most food photography projects, and is relatively simple to learn. The great thing about Lightroom is that alongside its comprehensive image-processing functionality, it also enables you to manage and print your images, as well as upload them to a variety of online photo sharing sites. This end-to-end functionality has earned Lightroom a reputation as a real all-in-one photo workflow tool.

Adobe offers a free 30-day trial version of Lightroom. If you decide you like it, you can purchase a full Lightroom 6 license for $149, or you can pay $9.99 per month for an Adobe CC (Creative Cloud) Photography subscription that includes the latest version of Photoshop, although you really don't need Photoshop to create great food photos.

Setting Up a Workflow

A sample Lightroom workflow could look like this:

- Import your images (if you aren't shooting in tethered mode) and apply filenames, keywords, copyright information, and any other metadata.

- View your photos and delete any blurred or otherwise flawed images.

- Process the remaining photos to taste.

- Export your processed images to JPEG for online viewing or printing.

In this chapter, I will use two real-world examples to take you through the entire image-creation process from start to finish. I will show you how to emphasize the atmosphere in an image, whether you're going for dark and mysterious or bright and breezy. None of the final images presented in the previous chapters looked that way straight out of the camera, and they have all been subjected to varying degrees of image processing.

The Lightroom interface is split into modules that represent the various stages of the digital imaging workflow. These are called *Library*, *Develop*, *Map*, *Book*, *Slideshow*, *Print*, and *Web*. This makes working with the software simpler, but you have to remember that certain functions are only available in certain modules. For example, you can't manage or import images in the *Develop* module; you have to switch to the *Library* module to do this. The following sections offer a step-by-step introduction to the basic Lightroom workflow.

Importing Image Files

Before you begin importing your images into Lightroom, I'd like to offer a few words about how the program works. Changes you make to your images are *non-destructive*, which means that any alterations you make are stored in a separate database rather than being saved as part of the image file. This database is called the Lightroom *catalog*. Put simply, when you make changes to an image, the results you view on your monitor are created by combining the original image file (on your hard drive) with the adjustment data saved in the catalog. When you process your images with Lightroom, remember the following:

- Your original image files remain unchanged.

- If you want to print processed images or upload them to an online site, you have to export them. Exporting an image creates a single new JPEG or PNG image file.

- To save a copy of your work, you have to back up your original image files and the Lightroom catalog.

When you import images into Lightroom, they are saved within a predefined folder structure on your hard drive and Lightroom makes a record of where each individual image is stored.

If you need to make adjustments to an image but don't have access to the original file—perhaps due to disk space issues or because you don't have the appropriate portable drive with you—you can use Lightroom's *Smart Preview* functionality to make changes to temporary copies of your images. This is a real boon, and I will explain how it works later on.

Image import takes place either immediately in real time if you are shooting tethered or via your camera's memory card.

Tethered shooting involves connecting your camera to your computer using the supplied USB cable. This enables you to view your photos on the computer monitor the moment you capture them and make any necessary changes to focus or composition right away. If Lightroom's tethering functionality supports your particular camera model, this is the simplest and best way to shoot.

Always rename, move, copy, and delete files and folders from within the Lightroom interface. If you manage your files and folders with a different program, the changes are not communicated to Lightroom and you will lose track of your images or even lose them altogether.

Tethered Capture

- To start a tethered session, switch your camera on and connect it to your computer. If the camera is not switched on, tethered shooting will not work. Switch to the Develop module in Lightroom and navigate to the *File > Tethered Capture > Start Tethered Capture* command.

- This opens the *Tethered Capture Settings* window, where you can make *Session*, *Naming*, *Destination*, and *Information* settings. Give your session a meaningful name so that you can easily identify it later. In my case, I called the session "Poffertjes." The *Segment Photos by Shots* option is only really useful for large projects with complex content, so I usually leave it unchecked.

- Use the *Template* drop-down to select a preset or custom naming convention for your photos. I used the Edit function to define the title "Poffertjes Dessert."

- Use the *Choose* button in the *Destination* section to define the target folder for your image files.

- The *Information* section enables you to add metadata and keywords to your files. I added the keywords "Poffertjes," "Dessert," "fruit," "sweet," "plate," "rustic," and "natural light" and created a new metadata preset for the photos included in this book (more on presets in a moment). Once you are happy with your settings, click on the *OK* button.

- The program creates a new folder according to your settings and you can now start shooting. The *Tethered Capture* window appears and displays the camera model, the current exposure parameters, and the session name. Once you have made all of the appropriate settings, you can click on the large, gray button in the *Tethered Capture* window to remotely release the camera's shutter. The remote release function is ideal for preventing unwanted camera shake during exposures. A second or two later, your image will appear in the Lightroom preview window on your monitor and as a preview in the Filmstrip at the foot of the main program window. You can now shoot away to your heart's desire.

Start a new tethered capture session in Lightroom.

Define a name for the new session.

Once you have defined your session, the Tethered Capture window appears at the top of the Lightroom program window.

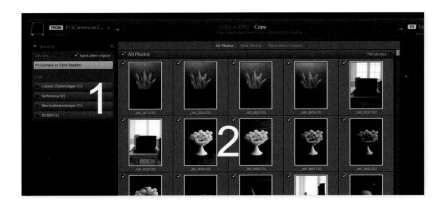

The session folder and its contents.

Importing Photos from a Memory Card

If your camera doesn't have tethered capture capability or you don't have a USB cable handy, you can import your images from your memory card. If your computer has a memory card slot that your memory card fits into, you can use that; otherwise, you will need to acquire a USB card reader that is compatible with your memory card. The following bullets explain the basics of image import in Lightroom. For more detailed information, see the software manual.

- Select the drive on which your photos are stored in the *Source* panel, and then select the files you wish to import by checking the box in the top left-hand corner of each thumbnail. Alternatively, you can check the *All Photos* box.

- You can now opt to save a copy of the imported photos to a separate drive, which is always a good idea. I always leave the *Don't Import Suspected Duplicates* option checked, as I often forget to delete photos I have already imported from my memory card.

- In the *File Handling* panel, *Build Previews* allows you to select the size of your previews. The options include *Minimal*, which produces the smallest possible previews and is the quickest; *Standard*, which produces previews according to the size you select in the program preferences; and *1:1*, which uses too much processing power and disk space to be of practical use.

- Check the *Build Smart Previews* option if desired. This is a really useful option that I always use.

- Whether you use the *Make a Second Copy To* option depends on the degree of security you prefer.

- The *File Renaming* panel enables you to apply new filenames to your images during import. There are various preset options and you can also define a custom renaming convention if you wish. If you select one of the preset "sequence" options, consecutive numbers are added to the filenames. It is up to you which options you select, but I recommend that you always use the same convention.

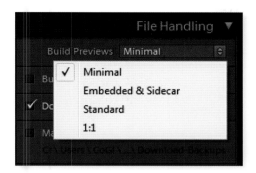

The Build Previews options.

More import options.

Applying filenames during import.

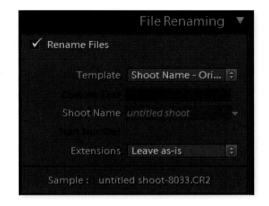

More file renaming options.

Editing a filename template.

The options you select appear automatically in the example window.

Saving the selected options.

- To customize a renaming convention, select the template you wish to customize from the drop-down list and select the *Edit* option. This opens the *Template Editor* window, where you can add custom fields or edit existing ones. For example, if you want to add a number and the year to the filename, select the appropriate options from the drop-down lists. The options you select appear automatically in the example window at the top of the template editor.

- Now navigate to the *Preset* drop-down list in the *Editor* window and select the *Save Current Settings as New Preset* command.

- Click on the *Create* button and select *Done* in the *Editor* window.

If you did everything right, your new preset is now available in the *Template* drop-down list in the *File Renaming* panel. That wasn't too difficult, was it?

- You can now add keywords (more on this later) and metadata to your files, and if required, you can add standardized develop settings such as lens corrections during the import process. Automating tasks during image import saves time and effort later on.

- The *Develop Settings* drop-down list includes a range of presets that you can apply during import. I don't recommend that you do this because most images require individual processing. Keywords are a great aid for finding individual images later on, but only if you apply useful, well-thought-out keywords in the first place. For example, if you have cooked up a

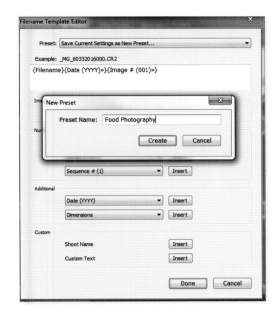

Give your new preset a name.

New presets are added to the program's built-in list.

The File Handling and File Renaming options.

Applying keywords and metadata.

The New Metadata Preset dialog.

Editing metadata fields.

It's definitely worth taking the time to keyword your images and add meaningful metadata tags. This makes it much easier to find individual images later on, especially if you are managing large numbers of files.

delicious pasta dish with tuna, you could add keywords such as "pasta," "tuna," "lunch," "tomato," "fish," and so on. To add keywords, enter them in the box, separated by commas, and select *Enter* when you are done.

- Use the *Metadata* options to add individual information such as the location of the shot or the camera you used. Select the *New* option in the drop-down list and add data fields as required.

- I recommend that you always use the *IPTC Copyright* field, but all other options are up to you. Review the various options and use the ones that best suit the project at hand.

- Give your new preset a meaningful name and select *Create* to add it to the list of available presets.

- Finally, select a destination folder for your imported image files, and if required, choose an additional backup location. Once you have made all of your settings, click on the *Import* button in the lower right-hand corner of the program window. Your images will now appear in the *Library* module.

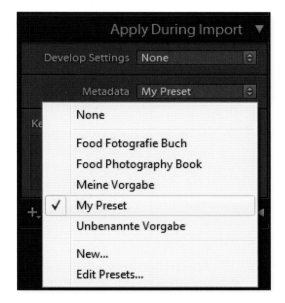

Applying a custom metadata preset.

Selecting an additional backup location.

Processing Your Images

Now that you have successfully imported your images, your final goal of excellent food photos is closer than ever.

If you are not happy with the way your images look straight out of the camera, programs like Lightroom offer countless ways to tweak them, and you will probably find that you end up spending more time processing your images than you do capturing them! However, it is all too easy to overdo image processing, and it is always a good idea to leave some time between shooting and processing. I usually examine my photos the day after a shoot to see which ones need further processing and which are okay as they are.

To process images in Lightroom, you have to switch to the *Develop* module. If you have captured RAW image files, the available processing options are virtually limitless.

A Classic Still Life Look

Do you remember the tomato and basil still life we looked at in chapter 4? The following sections explain how I achieved the dark and slightly mysterious still life look that characterizes this image. When processing your own photos, remember that there is no right or wrong way to develop an image. The most important thing is that you like the results.

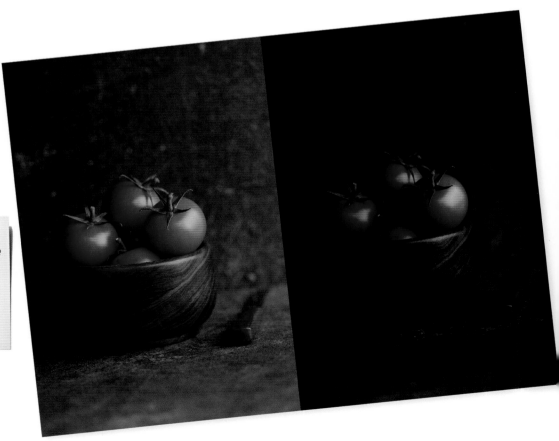

Before and after views of my tomato still life, with the processed version on the right.

Selecting an image in the Develop module.

Activating the Shadow and Highlight Clipping displays and the Lens Corrections tool.

- I began by selecting the photo I wished to process. I performed all of the following steps in the right-hand pane of the *Develop* module, following the order of the individual panels from top to bottom.

- Once I selected an image, I activated the *Shadow* and *Highlight Clipping* displays in the *Histogram* panel. These use blue and red highlights to indicate which parts of the image are under- or overexposed. In this example, there is one tiny underexposed area at the bottom left-hand edge of the container, which is of no real consequence to the overall look of the image.

- Next, I activated the *Lens Corrections* and *Profile* tools, which correct distortion and chromatic aberrations (color fringes that occur at high-contrast edges).

Adjusting white balance.

Reducing the Exposure setting to increase contrast. The white circle surrounds the only truly underexposed area, which is highlighted in blue.

- If you didn't set the white balance in the camera before your shoot, now is the time to use Lightroom's *White Balance* tool to select a neutral gray area within the frame—this acts as a reference for the white balance setting. Not all photos contain neutral gray details, so it pays to photograph a gray card every time you alter the lighting in your scene. As in this case, you will often find that the camera's built-in white balance functionality works perfectly and no adjustment is necessary. Try selecting various gray areas and check out the differences these make in the preview image at top left.

- I used the *Exposure* and *Contrast* sliders to make the atmosphere in my still life darker and more contrasty. The light in my photo came from the right, so the left-hand side of the subject was a lot darker, although my deliberate underexposure made the right-hand side darker too. The only truly underexposed detail is highlighted in blue. This had no effect on the overall look of the image, so I left it as it was.

*Using the Shadows and
Highlights sliders to
increase contrast.*

Making the image darker.

- I used the *Shadows* and *Highlights* sliders to brighten the tomatoes and slightly darken the left-hand side of the frame. These sliders only affect the darkest and lightest areas within the frame rather than the entire image.

- To lighten or darken the entire frame, use the *Whites* and *Blacks* sliders. The changes I made in this example are minimal and had more to do with gut feelings than with any real desire to alter the look of the image.

Don't sharpen your image too much.

Adding a vignette.

Using the Crop tool to straighten the image.

- I usually sharpen my images, but you have to keep an eye on the level of image noise when you do this. The more you sharpen, the more you risk producing visible noise artifacts. You have more adjustment headroom if you shoot at ISO 100 than you do at ISO 800.

- I also usually increase saturation in my images, but in this case I reduced it to underscore the classic look of the image. Always keep an eye on the reds when increasing saturation because they can quickly become oversaturated. If you don't like the result of an adjustment, use the *Undo* command in the *Edit* menu or the Ctrl+Z/Cmd+Z keyboard shortcut to undo it.

- I like to add vignettes to this type of photo. A vignette adds a slightly darker edge without producing an obvious frame effect. Use the sliders in the *Post-Crop Vignetting* tool to alter the effect to taste.

- Straightening is an important step in many food photos. You will often find that glasses, plates, and dishes are on a slight slant, especially if you were concentrating on other details during the shoot. The *Crop* tool in the *Tools* menu offers comprehensive options for cropping and straightening your images.

- Click within the frame to switch to a *100% view* when checking details. The regular Lightroom view is usually set to 20% or 30%, which isn't sufficient magnification for you to be able to detect all of the specks, spots, and visual flaws in an image. In my example, I used the *Adjustment Brush* to repair an unsightly blemish on one of the tomatoes. Use the sliders in the tool panel to adjust the size and density of the brush. The more you concentrate on details while you shoot, the easier post-processing will be.

Using the Adjustment Brush to make minor local corrections.

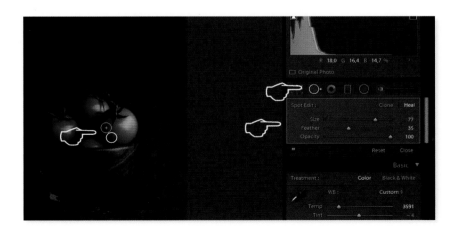

- The *Adjustment Brush* is ideal for adding highlight and shadow effects. In this example, I used a large brush and a *Highlights* setting of –78 to darken the shaded area on the left of the frame.

- At various intervals during processing, and once again before finally saving a file, I press the Y key to display before and after versions of my image. The original image wasn't bad, but I reckon the result of a few minutes spent processing is even better. What do you think?

If you like the results of a particular set of processing steps, you can copy them to similar images in your Lightroom library. To do this, right-click on the processed image in the filmstrip at the foot of the program window and select *Develop Settings > Copy Settings*. Now right-click on the image(s) to which you want to apply the settings and select *Develop Settings > Paste Settings*.

Using the Adjustment Brush to darken selected details.

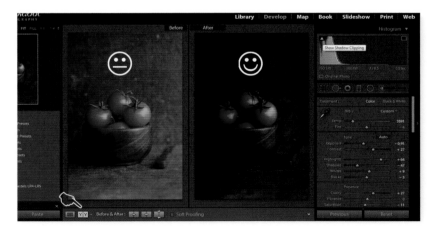

The original and finished images.

Saving Disk Space with Virtual Copies

Instead of making real copies of your image files, the best way to compare different versions and save disk space is to make virtual copies:

- Select the image you want to process in the *Library* module, right-click on it, and select *Create Virtual Copy*. This creates a copy that is displayed next to the original and is identified by a triangle icon in its lower left-hand corner. Create a copy for each look you want to try out. For my example, I made four.

- Process your copies as you would regular images.

- Switch back to the *Library* module and select your processed copies by clicking on them while holding down the Ctrl/Cmd key. Activate the *View > Survey* command.

- You can now view the various versions next to one another. The copies behave just like regular image files but take up much less disk space.

Creating a virtual copy.

Viewing a virtual copy in the Library module.

Displaying virtual copies.

Applying different looks to multiple virtual copies.

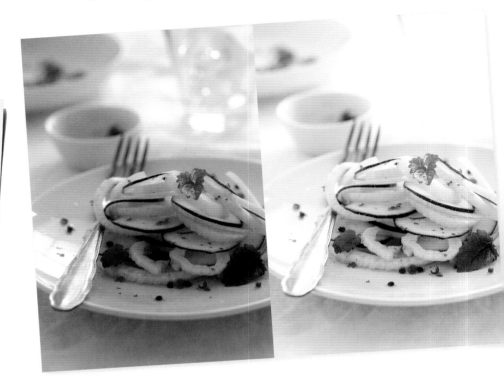

Before and after views, with the processed version on the right.

A Bright, Airy Look

This is pretty much the opposite of the look described in the previous section. The main prerequisite is a photo in which light tones dominate. Other than that, the steps involved are very similar to those described in the previous example. What do you think of the processed version?

- I began by activating the *Shadow* and *Highlight Clipping* indicators and switching on the *Lens Corrections* tool. The areas highlighted in red indicate overexposure (see page 171). Don't let the overexposure indicators influence your processing too much. Food photos often include bright reflections—in soups, drinks, and sauces, for example—so you have to ask yourself if these actually spoil the overall look of the image and whether they obscure details that are relevant to the effect you wish to create. Sometimes, bright highlights make a photo more interesting.

- I found the original image too dark, so I used the *Exposure* slider to brighten it. This also enlarged the bright highlights, although these still don't spoil the image.

- If necessary, check your white balance. I increased contrast to emphasize the individual slices of zucchini and slightly reduced the *Highlights* setting, which reduced the intensity of the reds.

Activating the Shadow and Highlight Clipping indictors and the Lens Corrections tool.

Using the Exposure slider to brighten the image.

Relax! All adjustments can be undone using either the Edit > Undo command or the Ctrl+Z/Cmd+Z keyboard shortcut.

Increasing contrast and reducing the Highlights setting.

Altering the Shadows and Whites settings.

Sharpening the image.

Increasing saturation to emphasize the colors.

Performing local corrections with the Adjustment Brush.

- I adjusted the *Shadows* setting to emphasize the darker areas and increased the *Whites* setting to balance the resulting look.

- As always, I sharpened the processed image. Be careful when sharpening—too much sharpening produces unrealistic-looking results.

- I increased saturation to add vibrancy. Here, too, care is required to keep things looking natural.

- The *Adjustment Brush* is perfect for retouching tiny details. In this case, I eliminated a couple of the red peppercorns to give the image a more balanced look.

- To finish up, I used the *Crop* tool to straighten the plate. The rest of the composition was fine, so no cropping was required.

- I switched off the overexposure indicator in the comparison view. Do you think the bright highlights spoil the image?

Straightening the finished photo.

Before and after versions.

Working with Presets

If you have ever wondered how some photographers manage to produce sequences of images with a unified look, wonder no more! Presets are the answer. Presets are sets of adjustments that you can save, name, and apply as often as you like to any of your images. This is similar to when we copied and pasted settings from one image to another on page 168. Lightroom has some built-in presets, although these are largely limited to black-and-white conversion effects.

If you already own Lightroom or are thinking of purchasing it, there are loads of online options when it comes to acquiring and applying presets. For example, search for "Lightroom presets" at *www.deviantart.com* for a wide range of free and commercial presets. Scott Kelby's *lightroomkillertips.com/presets* page offers free downloadable presets, as does *urban-base. net/lightroom-presets*. Even if they aren't explicitly aimed at food photographers, many are worth trying out. If you don't find what you're looking for at the sites I've mentioned, use your favorite search engine to look for "free Lightroom presets"—you are sure to get plenty of hits. Last but not least, if you can't find any ready-made presets you like, make your own. Read on to find out how.

Installing and Managing Presets

Some commercial presets, such as those from VSCO, have their own installer that works like a regular application—all you have to do is double-click on the file and follow the on-screen instructions. Most other presets are available in the compressed ZIP format that you have to unpack prior to installation. Most operating systems have an Extract command built into the file management interface that you can apply by right-clicking on a zipped file. Extracted Lightroom presets have the *.lrtemplate* filename extension. To keep track of unzipped presets, create a new folder called *LR Presets* (or something similar) on your desktop and extract the template files directly to it. Once you have unpacked your presets, proceed as follows:

* Start Lightroom, switch to the *Develop* module, and navigate to the *Presets* panel in the left-hand pane. Now right-click anywhere in the gray title area and select *New Folder*.

* Give the new folder a meaningful name in the window that appears. Presets folders are displayed in alphanumerical order, so giving your new folder a name that begins with "1" is a great way to make sure it appears at the top of list. Now click on the *Create* button. I called my sample folder "Food Saturation."

* The new folder will now appear automatically in the *Presets* panel. Click it to highlight it in light gray, and then right-click it and select the *Import* command. Select the folder where you stored your unzipped presets, double-click the folder to open it, select all files with the *.lrtemplate* filename extension, and click *Open*.

* Many presets have long or complex names, so it makes sense to change them to suit your needs. To do this, right-click each file, select *Rename*, and type in your chosen name. Click *OK* to confirm your changes.

Now you have installed your presets. Let's start using them!

Creating a new presets folder.

Naming the new folder.

Opening the new folder.

Installing presets.

Preparing to rename the presets.

Renaming a preset.

Freshly installed presets are automatically available in the Presets panel.

Selecting a preset.

Applying Presets

- Select a photo and open the *Presets* panel on the left. If you installed your own presets correctly, they will automatically appear in the list.

- A preset overwrites any other settings, but you can make additional settings once you have applied it.

- The preview at top left displays a preset's effect in real time when you select it. If you like what you see, simply click the preset to apply it to your image. The sliders in the right-hand pane are adjusted automatically when you apply a preset, making it easy to see which adjustments it makes. You can leave the resulting image as it is or fine-tune the slider settings as necessary. Adjusting the sliders doesn't alter the preset itself.

- To undo a preset, click the *Reset* button in the bottom right-hand corner of the program window.

These three photos show the different looks created by applying different presets.

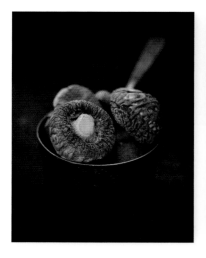
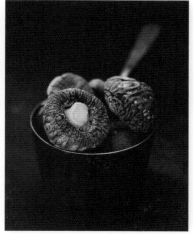
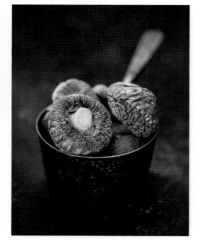

The results of applying three different presets. ISO 100, 1/50 second, f/5.6, 100 mm

Managing Presets

Some photographers collect presets the way they collect props. If this includes you, never fear! Lightroom includes functionality that helps you keep track of large numbers of presets. You can rename your custom folders and move presets between them, but you can't reshuffle Lightroom's built-in presets. Moving and renaming presets and folders is relatively simple. The difficult part is creating and sticking to a practicable folder structure.

To rename a presets folder, simply right-click on it and select the *Rename* command. You can also drag presets to a different folder using your mouse and rename them as explained previously.

Creating Your Own Presets

Presets are a lot of fun and can save you a lot of time. To create your own preset, follow these simple steps:

- Select a photo and make the settings you wish to save as a preset. In this example, I altered the *Exposure*, *Contrast*, *Clarity*, and *Saturation* settings. Because these are settings I adjust for most of my photos, it makes sense to bundle them in a preset that I can apply with the click of a button.

- Once you are happy with the settings you've made, click the "+" icon at the top of the Presets panel. This opens the *New Develop Preset* window, where you can give your new preset a meaningful name and select the settings you want it to include. I recommend that you stick to using the default *User Presets* folder. Click *Create* to save your preset.

- Your new preset will now appear in the *User Presets* folder and you can apply it in the usual manner.

Even if you use presets, don't forget to give each image the individual finishing touches it requires. Custom *White Balance* and *Adjustment Brush* settings are particularly important.

Make the settings you wish to save as a preset.

Give your new preset a name and check the boxes next to the settings you want it to contain.

Select your new preset in the Presets panel.

If you use presets, make sure the photo you select is appropriate for the effect you want to apply. Still lifes and other images with plenty of negative space are often suitable candidates, but not all food photos benefit from the application of presets.

Adding a filename and a title. *Renaming a file.*

Getting Organized

Now that you have processed your precious photos, published them on your blog, or perhaps turned them into a photo book with recipes for your mother-in-law, what comes next? It is impossible to overstress the importance of keeping your photos organized, and the start of your food photography career is the best time to come to grips with this deceptively tricky task. There is nothing worse than searching in vain for a photo you shot six months ago, only to find you assigned it the wrong keywords, mistitled it, or simply forgot where you put it. Make sure that you are fully in charge of your images right from the start. There are loads of great photo management programs around, but if you already own a copy of Lightroom, you need look no further.

Whichever program you use, it is essential to give each of your images a title and at least a couple of meaningful keywords immediately after a shoot. Giving an image a punchy title is the best way to guarantee you will find it again later on. In the case of food photos, the obvious choice is the name of the dish or the drink. The example here is a photo of some brussels sprouts. Don't use more than one or two words if you can avoid it.

Changing a Filename

- To change the name of a file in Lightroom, switch to the *Library* module, select the photo, and navigate to the *File Name* field in the *Metadata* panel on the right, where you can type a new name. Select *Enter* to confirm the change. Remember to always stick to the same naming convention.

- The new filename will appear in the toolbar at the foot of the main preview window.

Selecting a folder to rename.

Changing a Folder Name

- To rename a folder, right-click it in the *Library* view, select *Rename*, and type a new name in the box that appears. Select *Enter* to confirm the change. Your new folder name will appear in the *Folders* panel.

Adding Watermarks

If you publish your photos on the Internet, it is a good idea to add a watermark to each image. Watermarks make it easier to track ownership of a photo and also provide an opportunity to give your homepage or blog extra publicity.

The photo on the right was processed using a preset and includes a custom watermark in the bottom left-hand corner. You can use any text you like in your watermark, from complex ownership data to a simple title.

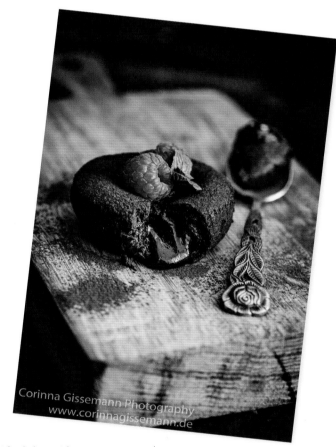

A food photo with a custom watermark.
ISO 100, 1/20 second, f/4.5, 100mm

Activating the Watermark Editor.

The Watermark Editor window.

Entering text.

Selecting text and shadow options.

Follow these steps to create a watermark:

- Switch to the *Develop* module, select a photo, and navigate to the *Edit Watermarks* command (this is in the *Edit* menu on Windows-based computers and in the *Lightroom* menu on a Mac).

- The *Watermark Editor* window will appear.

- Enter your text. To keep this example simple, I chose *Corinna Gissemann Photography www.corinnagissemann.de*. Pressing the enter key adds a new line and you can view the results in real time in the preview window.

- The default settings are rarely appropriate so you will usually need to make some changes. As always, the settings you choose are a matter of taste, although I don't recommend using fancy typefaces because they are often tricky to read. I also recommend sticking to black or gray type on light backgrounds, or white type on dark backgrounds. As we have already seen when choosing props, bright colors distract the viewer from the real subject. A watermark is a subtle reminder, not an advertisement.

- Lightroom offers various watermark options. In the *Text Options* section, you can alter the font, font style, color, and alignment. I selected right-justified. You can also add a shadow with adjustable opacity, offset, radius, and angle settings. In my example, I used the Lightroom defaults.

- The *Watermark Effects* section includes opacity and size sliders, and I recommend that you keep your watermarks small and semi-transparent but still readable. In my example, I set opacity to 50% and used the *Proportional* text size option. The *Fit* and *Fill* options stretch the watermark to cover the entire frame, an option that doesn't suit food photos at all.

- The tools for altering vertical and horizontal inset are self-explanatory. I shifted mine slightly to the right to prevent it from looking like it's squashed up against the edge of the frame. There is also an *Anchor* option that enables you to rotate and precisely position your watermark within the frame.

- Once you are happy with your settings, click on *Save*, give your new watermark a meaningful name, and select *Create*.

- Watermarks are embedded in images at the export stage, which is why your new watermark hasn't yet appeared in the preview image. See page 183 for more details on exporting images.

- You can rename or delete a watermark, or edit it via the *Custom* option in the *Edit Watermarks* menu.

- Once you are done editing your watermark, click *Save*.

In addition to the default options, you can also use a custom graphics file as a watermark. However, going into detail on creating graphics is beyond the scope of this book.

Adjusting the opacity and text size.

Altering the position of the watermark.

Give your watermark a name.

Activating a watermark during image export.

Assigning freeform keywords to an image.

Selecting keywords from a list.

Keywords are easy to edit or delete.

Adding Keywords

Keywords are just as important as the title of an image and need to be appropriate to the image at hand. There are no limits to the keywords you can assign, and you can use them to denote the mood, color, subject, season, ingredients you used, or any other relevant attributes.

You could, of course, use themed culinary keywords such as breakfast, lunch, vegetarian, or vegan. If you are just staring out, it is a great idea to use descriptive keywords such as daylight, artificial light, backlight, reflector, fill, and so on. This way, you can easily refer back to the techniques you used. I often take an overview photo of a set that I use to help me reproduce a certain mood on a later shoot. If you find you have mistyped a keyword or simply left one out in the heat of the moment, Lightroom makes it simple to edit your keywords and other metadata.

- Switch to the *Keywording* panel in the Library module and select an image. The *Keywording* panel offers *Keyword Tags*, *Keyword Suggestions*, and *Keyword Set* sections. If your photos already have keywords assigned to them, the last two sections will already display appropriate content. Clicking on a keyword assigns it to the currently selected photo. To add new keywords, type them into the *Keyword Tags* box, making sure you separate individual keywords with a comma. Press the enter key to save new entries.

- The *Keyword Suggestions* section contains suggestions generated automatically by Lightroom. These are based on the keyword frequency, the presence of photos that contain similar keywords, and how recently a photo was captured.

- The *Keyword Set* section can be used to group sets of related keywords that you can then apply to photos in a similar way to develop presets.

- Lightroom displays all available keywords in the *Keyword List* panel and displays a checkmark next to the ones currently in use. Here, too, you can add keywords that you have previously added to other images. If you want to delete or edit a keyword, right-click on it. This opens a context menu with options that include *Remove This Keyword from Selected Photos*, *Delete*, and *Edit Keyword Tag*. Newly added keywords are immediately available for assignment to other photos.

Exporting Images

As I explained at the beginning of this chapter, the processed photo you see in the Lightroom preview window is the product of applying the settings and adjustments you make (which are stored in the Lightroom catalog) to your original image file. If you want to use a processed image in a different environment—on your website, for example—you have to export it first. This process creates a new image file with your changes embedded in it.

Follow these steps to export a processed image file:

- Right-click on your image to open the context menu and select the *Export > Export…* command.

- This opens the *File Export* dialog, where you can select the export location, a file naming convention, and, in the *File Settings* section, the file format, quality, and color space settings for your exported file. For Internet use, you will usually choose the JPEG format, but TIFF is preferable if you want to further process your image using a different program such as Photoshop. When selecting a quality setting, remember that higher quality means larger files.

- If you want to add a watermark, check the *Watermark* option in the *Watermarking* section. The default setting adds a simple copyright watermark, but you can also add your own custom watermarks, as described previously. Click *Export* to export your image to the location you selected.

- To export another image using the same settings, open the context menu and select the *Export > Export with Previous* command. This command will attempt to create a new file with the same name as the previous one

Accessing the Export dialog via the context menu.

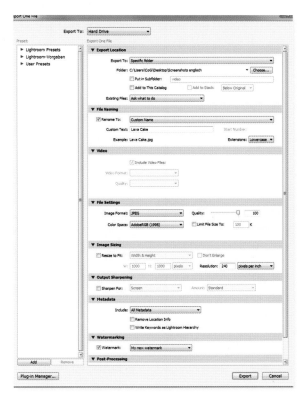

The settings available in the Export Files dialog.

183

Lightroom warns you if you attempt to export a file to a location where that filename already exists.

and automatically opens the *Problem Exporting Files* dialog to help you deal with the issue. Click the *Use Unique Names* button to create a new file with a sequential number. Repeat this step for each image that you wish to export with the same settings.

Backups

It is important to regularly back up your original image files and your Lightroom catalog. The best place to keep backups is on a portable hard drive. You know where you keep your originals, but if you are not sure where the catalog file is stored, go to the Lightroom menu and select *Catalog Settings*. Click the *Show* button in the *General* tab to go directly to the appropriate location. The file you need to copy is called *Lightroom-Catalog.lrcat*.

The Backup section in the General tab offers options for automatically creating a copy of the catalog. This backup is stored on the same disk as your Lightroom installation, so if your hard drive crashes, your catalog copy will die with it. This is why I encourage you to create manual backups and store them on a portable drive. It pays to back up your catalog at least once a week.

As you can see, Lightroom is an extremely powerful image management and processing tool. If you need assistance, check out the Adobe online help pages at:

https://helpx.adobe.com/lightroom/topics.html

Have fun getting to know Lightroom!

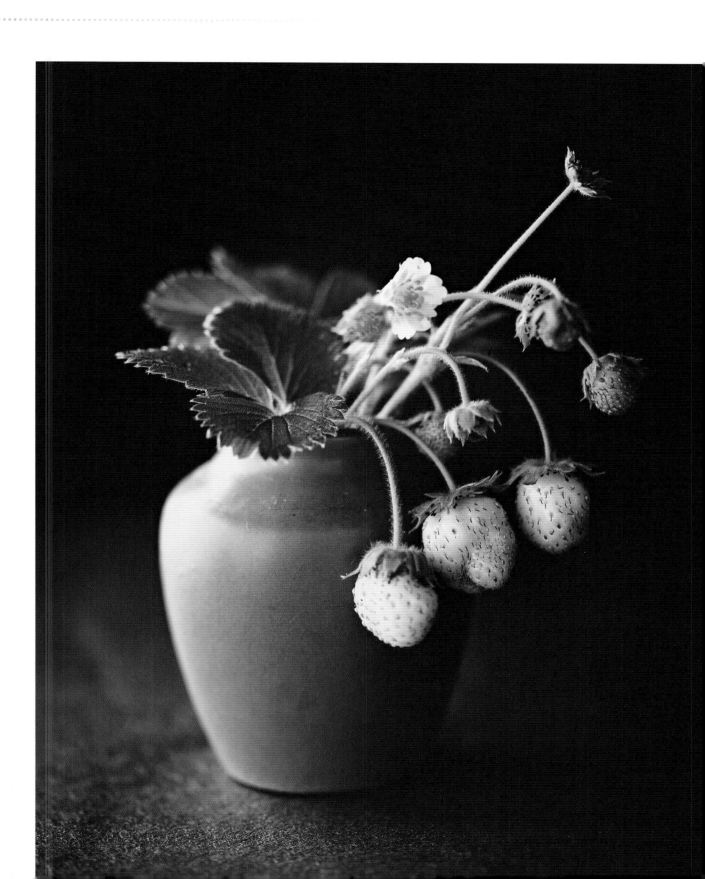

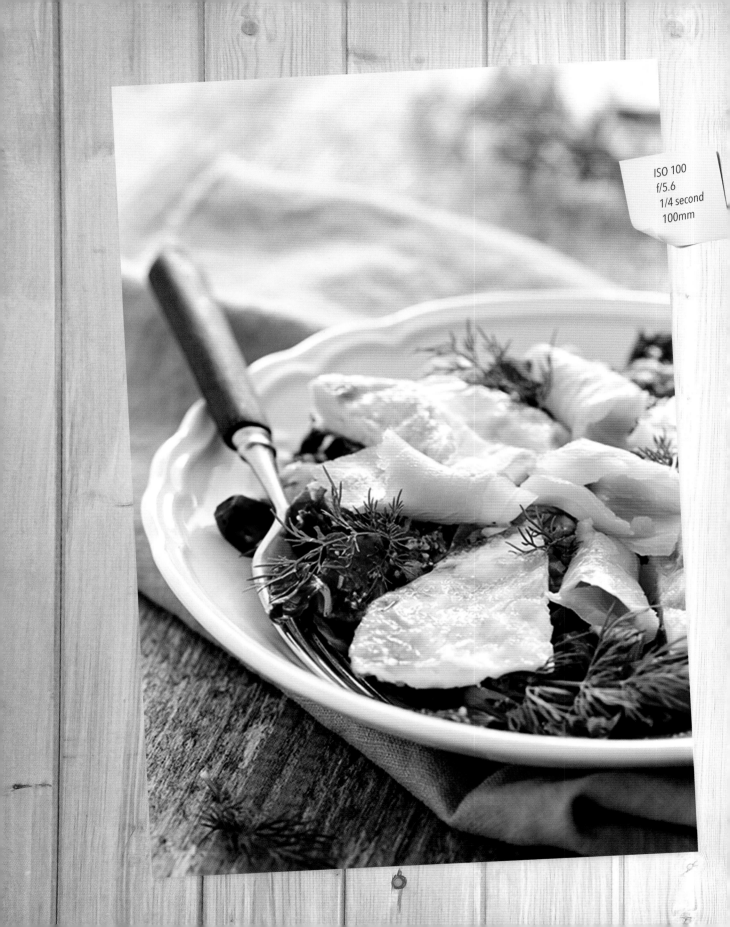

ISO 100
f/5.6
1/4 second
100mm

CHAPTER 8
Tips and Tricks

Food photography would be a pretty dull pastime if it weren't for all the clever little tricks that make it so much fun. This chapter is not about pro-grade tricks for creating high-end studio shots, but rather the little gimmicks that make life easier when you are starting out.

Have you run into the same problem several times and you simply can't solve it? Perhaps the foam on a beer collapsed or the vegetables in a soup have sunk to the bottom of the bowl. If you have ever been frustrated by issues like these, have no fear! Help is at hand. Once you have read through this chapter, the world will seem like a simpler place. Even the most experienced photographers have bad days or ideas that simply don't work out—that's all part of the deal.

As you gain experience, you are sure to develop your own work-arounds for tricky situations, and the only rule is that the technique you use mustn't be visible in the finished photo, whether you use toothpicks to keep a burger together or kitchen towels to fluff up your pancakes. But you know this, right? After all, you are already well on your way to becoming a great food photographer.

A few drops of condensation would make this drink look even more enticing.

ISO 100, 1/5 second, f/7.1, 100mm

A couple of squirts of our water and glycerin mixture…

…make the drink look fresher and even more irresistible.

ISO 100, 1/5 second, f/7.1, 100mm

When photographing drinks, it's always handy to have a spray bottle filled with glycerin and water nearby.

Simulating Condensation

Ice-cold drinks are perfect for a hot summer's day, but to get them looking just right, you definitely need one of the spray bottles I mentioned in the "Styling Kit" section of chapter 5 (see page 88), which can do more than just keep vegetables and salads looking fresh. Condensation dripping down a bottle or glass always makes a cold drink look authentic, and if you paid attention in physics classes, you will know why. Cold air cannot hold as much humidity as warm air, so when warm air hits a cold glass, droplets of condensation immediately form. To recreate this situation artificially or add a few extra droplets to a scene, mix some glycerin with water in a 1:1 ratio, transfer the mixture into a spray bottle, and spray fine droplets anywhere you want. Be careful not to touch your artificial droplets with your fingers because they smear easily and are tricky to remove. And always use a kitchen towel to prevent the spray from hitting your background and other props.

You can see a burned-out highlight in the base of this glass.

Placing a small piece of white paper behind the glass…

…makes the highlight disappear, as if by magic.

Combating Burned-Out Reflections

If you have spent any time photographing smoothies, shakes, and cocktails, you've probably noticed that burned-out highlights often appear in the base of drink glasses. If highlights like this get too large, they can easily distract the viewer and spoil a photo. I searched online to find the solution to this problem and discovered that if you carefully place a small piece of white paper behind the glass, the burned-out highlights disappear (see the photos above).

Stabilizing Styrofoam Reflectors

When I was just starting out as a food photographer, I quickly built up a collection of broken pieces of Styrofoam that I used as reflectors. But I had a problem getting them to stay standing once I had positioned them on my set.

 This issue cost me a lot of nerves until I came up with the idea of taping a bottle of water to the back of the Styrofoam to act as a counterweight. You can use a metal bracket or a cardboard box too—the main point is that the reflector stays put. Reflectors equipped this way stand up to a lot more punishment than a simple sheet of Styrofoam.

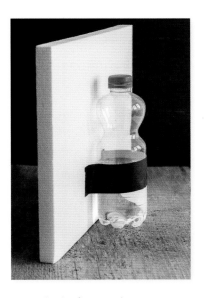

Using a bottle of water and some tape is a great way to stabilize a Styrofoam reflector.

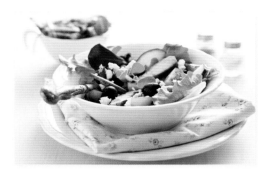

This salad looks good but lacks volume.
ISO 100, 1/5 second, f/6.3, 100mm

A small upturned bowl can work wonders.

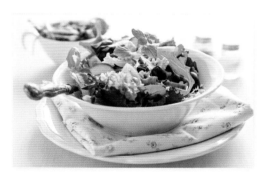

The extra bowl makes the dish look much fuller.
ISO 100, 1/6 second, f/6.3, 100mm

The "Full Dish" Trick

The next trick addresses the issue of adding volume to the contents of a dish or bowl. Maybe you have already come across this trick or come up with the same idea yourself. All you have to do is place a small, upturned bowl—or half an apple, or anything else that would create a small mound—in your main bowl. You can then assemble your ingredients on top of it to make your dish appear full using just a little of your carefully prepared food. This is a really simple trick that makes a big difference.

Salt in Your Beer

If you have ever used a glass of beer as a background prop, you are sure to have been frustrated every time the foam collapses while you work on your other props. To combat this, simply pour a little salt (and I really mean a little) into the beer. The effect is immediate. But beware—too much salt makes a real mess!

Gelatin Soup

When you're photographing soup, vegetables and other garnish tend to sink to the bottom of the bowl before you are ready to shoot. You can solve this problem with gelatin. Prepare some gelatin according to the instructions on the package and fill your soup dish halfway with the warm gelatin liquid.

Allow both the gelatin and your soup to cool separately, and then carefully pour your soup onto the layer of gelatin in the bowl. If the soup is too hot, it will mix with the gelatin. Now style the ingredients and garnish

Left: A base layer of gelatin prevents ingredients from sinking to the bottom of a soup.

Right: The gelatin disappears beneath the soup but holds up the contents of the bowl.
ISO 100, 1/10 second, f/5.6, 100mm

on the surface of the soup and voilà, your ingredients stay in full view instead of sinking to the bottom of the bowl.

Building Blocks as Placeholders

If your shot is set up and ready to go but you have to remove or restyle the subject at the last second, a quick visit to your child's room can save the day. Grab a few building blocks and use them to mark the position of the subject while you take it away and adjust it. If you don't have building blocks handy, buy a piece of wood at a hardware store and saw it into chunks. In fact, anything that cannot be blown askew in a breeze will do. You will quickly learn to love these little helpers since they save a lot of time and trouble when you have to reposition your dishes and props.

Building blocks can be used to mark the position of a prop on set.

The space is precisely marked while you fill the plate for the shoot.

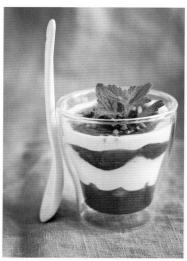

A cardboard box makes a great stand for a fabric background.

This impromptu background is ideal for capturing small dishes like this dessert.
ISO 100, 1/6 second, f/5.6, 100mm

Cardboard Backgrounds

If you have limited room for your photographic experiments, an improvised tabletop studio is a great way to make the most of the available space. If you find that your own domestic surroundings show up too much in the background of a shot, try using a cardboard background. Cardboard backgrounds are stable, lightweight, and portable, and they can be used to conjure up a studio-like feel in any corner of a room.

Four Eyes Are Better Than Two

You know the feeling: you have been working hard on a shot, you have removed the last few unwanted crumbs, folded a napkin to perfection, and captured your "perfect" scene in all its glory. But then you realize there's a basil leaf where it shouldn't be and you are faced with the dilemma of either simply hoping no one will notice or spending hours retouching your photos.

Sometimes these things just happen, even to the best photographers, and a great way to avoid this kind of situation is to get someone to look over your shoulder while you work. This can be a member of your family, a friend, or a fellow photographer. Listen carefully to their observations—four eyes are often better than two.

Making Notes

Even if you are a dyed-in-the-wool cell phone user, or a tablet has long been part of your daily life, an old-fashioned notebook is still the best way to record ideas, sketches, important details about your setups, and whatever else occurs to you while you work. When was the last time you wrote anything by hand? But I digress. A notebook is simply a nice thing to have and use.

At this point, I could go on about using shaving cream instead of foam on a cappuccino, or how to create faux vanilla ice cream using sugar and margarine, or how to make delicious-looking chocolate candies from synthetic resin, but that's not really the point of food photography. To me, it is all about capturing great photos and then getting to eat the fruits of your labor as a kind of reward. However, if you get really stuck, check out www.displayfakefoods.com for a laugh. You will see that anything is possible.

Have fun and keep experimenting!

ISO 100
f/5.6
1/13 second
100mm

CHAPTER 9

Homemade Props

Starting out in food photography can be quite expensive, what with cameras, lenses, and seemingly endless props. One way to save money is to make your own props—after all, every little savings helps!

Food photographers often turn into passionate tinkerers, motivated by the urge to build, create something original, or simply save money. I cannot resist the temptation to get out my brushes and make a new background. But that's not all you can do. How about using fabric remnants to sew your own napkins or making an everlasting milk bottle? This chapter explains how to make this and a bunch of other really useful props at home.

I love the personal touch that homemade props give a food photo, and there are countless webpages full of ideas on the subject. Take a look around your home and try to see just how many of the objects that surround you can be used as props for your photos. Or take a look around your parents' house—you will be amazed at what you can find.

Grab a milk bottle and pour some white paint into it.

Roll the bottle around until the paint covers the inside.

Add a straw to make a convincing fake bottle of fresh milk.
ISO 100, 1/8 second, f/5.6, 100mm

Trick Milk Bottle

The first of my homemade props is an everlasting milk bottle. This effective little gimmick requires very few materials and is easy to make.

- Pour some white paint into an empty milk bottle, taking care not to splash it around the neck. I used cheap paint from a hardware store.

- Lay the bottle down and roll it around until the paint is evenly distributed on the inside. If the paint doesn't spread easily, pick up the bottle and tilt it carefully back and forth before rolling it around some more to finish the job.

- Make sure the upper edge of the "milk" is level, and leave the bottle and paint to dry.

Add a straw, and you're done! There are countless situations in which a bottle of milk adds flavor. You can also paint bottles in pastel colors to use as vases or background props.

Tongue-and-Groove Background

A food photographer can never have enough backgrounds, and making new ones at home is a lot of fun (as long as you don't ruin your furniture in the process). White backgrounds are neutral and can be used in most situations, while brown is better for darker, rustic-style shoots. Dark greens and blues often work well on food shoots, whereas bright green and red tones tend to distract the viewer from the food. Two-color backgrounds with a weathered look are particularly effective and add texture to your photos.

To make a custom background, follow these steps:

* Purchase a few tongue-and-groove boards from a hardware store and get the store to cut them to length for you. I get mine cut in half and prepare both halves the same way. This gives me two separate backgrounds that I can place beneath and behind a subject as required.

* To prepare the boards, you need a sponge, primer paint, paint in the color of your choice, a large paintbrush, a roll of paper towels, coarse sandpaper, and colored wax for the finish.

* Begin by painting your boards with undiluted primer, and don't forget to open the window while you work! It doesn't matter if the surface isn't evenly covered—bare wood showing through here and there enhances the look of the finished background. Let the primer dry.

Left: The tools I used to make my tongue-and-groove background.

Right: Apply a thin layer of primer.

Left: Use a sponge to apply the darker surface color.

Right: Roughen the surface with sandpaper.

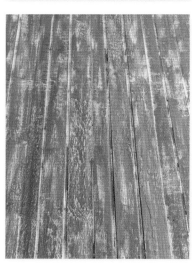

Left: Seal the finished surface with wax.

Right: The finished background.

- Use your sponge (I cut a bath sponge into two pieces) to apply the colored paint to the dry primer layer with varied strokes and daubs. If you let the primer show through in random places, it accentuates the weathered look of the background. Leave the second layer of paint to dry.

- Now sand the surface of the painted wood using the sandpaper. Use varying degrees of pressure so that the primer shows through in some places and bare wood shows through in others.

- To complete the background, apply wax using paper towels. Again, if you apply random amounts, it emphasizes the authentic look of your background.

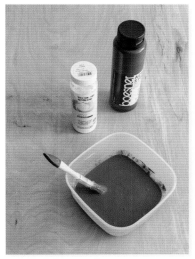

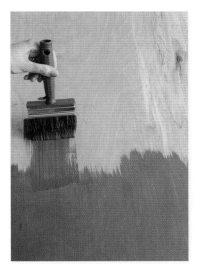

The materials I used.

Dilute the dark paint with water.

Apply the diluted paint.

Plywood Background

Plywood is lighter and thinner than other types of wood, making it easier to transport and store. The following steps show you how to make an effective, light-colored background from a sheet of plywood.

- Once again, you need two different colored paints, a paint-brush, plastic dishes for mixing the colors, sandpaper, and paper towels. Begin by diluting the darker paint with water. This makes it easier to apply and allows the wood grain to show through when you are done.

- Apply the diluted paint to the entire surface using the paint-brush and allow it to dry.

- Now apply the undiluted light-colored paint using random strokes and just the tips of the bristles. This allows the base color to show through.

Fill a plastic bowl with your light-colored paint and apply it in daubs using the tip of your brush.

- Use your sandpaper to roughen the surface. Rubbing up the finish in varying directions gives the surface a wonderful shabby chic look and feel.

- Now add a second layer of diluted light-colored paint using quick, gentle brushstrokes.

- Use paper towels to clean off any excess paint. The result is a bright new background that you can use on your next shoot.

Left: Roughen up the surface with sandpaper.

Right: Apply a second layer of diluted white paint.

Left: Remove excess paint with paper towels.

Right: The finished background.

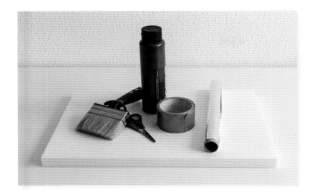

The materials I used to make my reflector/flag.

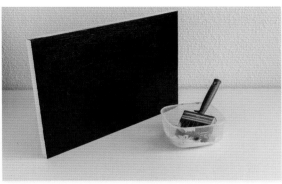

Paint one side of the Styrofoam sheet black.

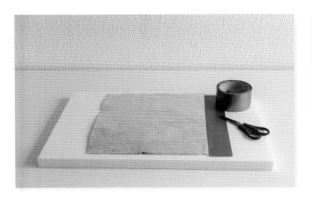

Tape aluminum foil to the other side.

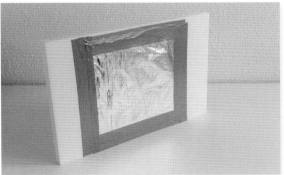

The finished light shaper.

Two-in-One Reflector and Flag

This useful light shaper is effective and simple to make, and is great if you are working with limited space.

- To create a simple flag, cover one side of a piece of Styrofoam with black paint.
- To turn your piece of Styrofoam into a multipurpose tool, you can tape aluminum foil to the reverse side of your flag to turn it into a fill reflector. You now have a lightweight two-in-one studio light shaper.

The materials required for a DIY soup can.

Empty the can and remove the label.

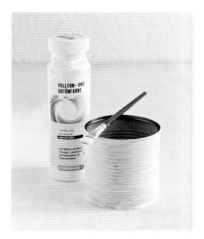

Paint the can with white primer.

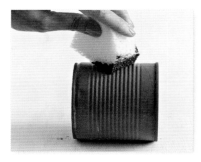

Apply the darker paint with a sponge.

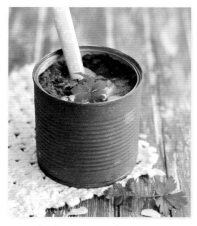

A sample photo using the finished prop. Do you recognize the background in this shot?

Universal Soup Can

Soup cans in food photos? Sure, why not! With a bit of practice, you can turn a nondescript soup can into a fine prop. All you need are a can (ideally one with a ring-pull so you don't end up with sharp edges), a sponge, a paintbrush, and two different colored paints.

- Empty your can, wash it out, and remove the label. Now apply the primer color and let it dry.

- Apply your second color by dabbing lightly with a sponge. This adds texture and allows the base color to show through a little. You could roughen the surface a bit with sandpaper, but I found my can looked fine as it was.

- Cans are food safe, so there is no reason not to eat food that was placed in it after you shoot with your new prop.

- Make sure you don't wash off the paint when cleaning your can.

Decorated Teacup

Although white tableware can be used almost universally in food photos, a dab of color doesn't do any harm now and then. Gather a dish of warm water, some nail polish (one or two colors depending on how adventurous you are feeling), and a cup, and follow these steps to create a fun new prop:

- Add a few drops of each nail polish to the warm water.

- Dip the parts of the cup you wish to adorn into the water.

- Remove the cup carefully, allow excess water to drip off, and let it dry—it's that simple.

Left: The materials I used to decorate my teacup.

Right: Add a few drops of nail polish to a dish of warm water.

Dip the cup into the water.

Next page: Yet another homemade prop in action.
ISO 100, 1/8 second, f/6.3, 100mm

A coffee cup and saucer can easily be transformed.

Turn the cup over and place the saucer on top of it…

…and you have an instant mini cake stand.
ISO 100, 1/6 second, f/5.6, 100 mm

Five-Second Mini Cake Stand

And finally, here's the quickest prop of all. This mini cake stand is the perfect addition to photos of muffins, macaroons, or any other cookies and pastries. And best of all, you can still use the cup to drink from later.

- Find a matching cup and saucer.
- Turn the cup over and place the saucer on top.
- Fill the saucer with tasty treats and shoot!

Have fun putting these ideas into action and inventing your own props!

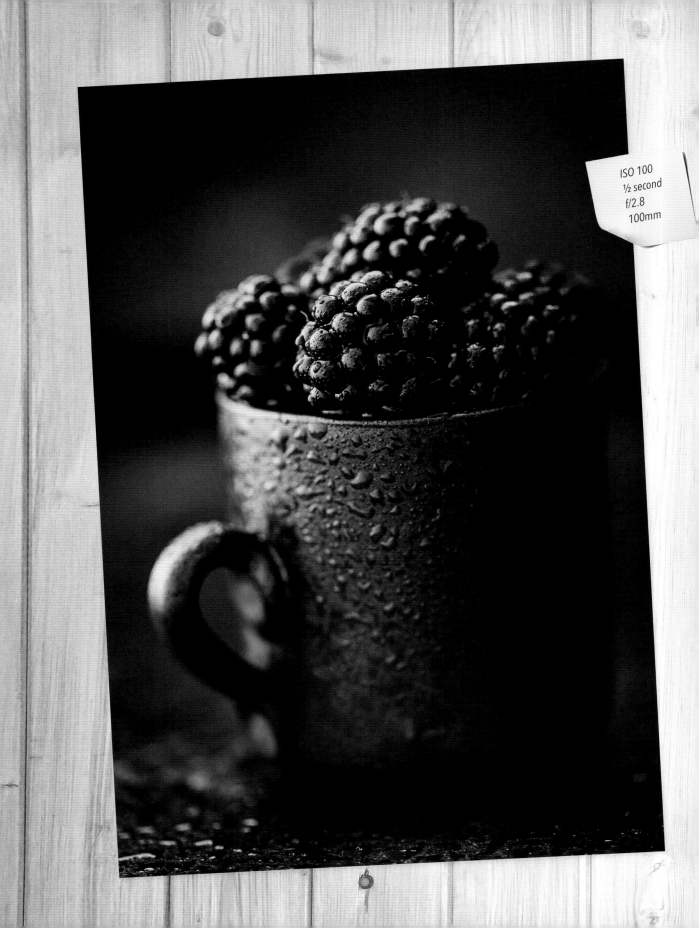

ISO 100
½ second
f/2.8
100mm

CHAPTER 10

How to Boost Your Creativity

Whether you are just starting out or are already working on improving your technique, it is essential to keep learning to see the world around you with fresh eyes. No one can create great food photos without practice. Perhaps there are one or two people who can do anything they like with no effort, but I'm talking about you and me and all the other "normal" people out there.

If you have read this far, it is probably because you love cooking and want to show your culinary creations in the best possible light. And as you have learned in the course of this book, there is more to successful food photography than just serving up a dish and pressing the shutter button.

At some point or another you may end up feeling kind of empty; your photos will all look the same, and you won't be able to turn your ideas into reality. If this is the case, the only thing to do is take a break. Don't even touch your camera for a couple of days and do something else you enjoy instead. But always keep your eyes open for new inspiration, and let the things you see during your daily routine steer your thoughts in new creative directions.

Many photographers end up getting stuck in a kind of creative comfort zone. Their cameras and tripods are always positioned in the same way, and the shooting angle and props they use never change. This approach may require less effort, but it sure makes life dull.

I know the feeling when you simply can't produce any new ideas, and this is the point at which you need to find a solution. This chapter covers a number of ways to help you keep your photography fresh and develop your style, even when you are in the middle of a difficult creative phase.

Get Out of Your Comfort Zone

If you're on a shoot and find yourself photographing from the same angle and making the same old camera settings, it's time for a change. Trying something new is the easiest way to discover fresh inspiration. This can mean shooting in backlight instead of lateral light; or at f/2.8 instead of f/5.6; or in landscape format instead of portrait format; or you can try altering your composition to include more negative space than you typically use.

Old habits can be frustrating, so break with tradition and do everything differently for once. Shoot from a viewpoint you don't normally like or use a different lens. You will quickly find that changing just a single element on a shoot can lead to a whole bunch of new ideas. Challenging your own preconceptions is the best way to discover new passions, and you might even end up taking your photography in a whole new direction.

Imitate Your Role Models

There is nothing wrong with copying and adapting other people's ideas. I often shoot my own versions of food photos taken by other photographers that appeal to me. After all, many aspects of human life involve learning by doing, and it's never too late to learn.

My first tip is to search actively for role models. Look for food photos—either online or in print—with a visual language and compositions that fascinate you. Take the time to analyze what it is about a photo that you particularly like and how it affects you. How did the photographer manage to create and communicate a particular mood? If you get hungry looking at a food photo it means the person who made it did everything right, right? If a particular photographer catches your eye, let her style become your guiding light for a while.

Once you have found some inspiration, it's up to you to use it to develop your own style and make new images. If you publish images inspired by the ideas of others, be sure to include plenty of your own ideas as well, and credit the originator where appropriate. Imitation is the highest form of flattery, but plagiarizing is just cheap.

Learning to "Read" a Photo

Analyzing other people's food photos can be really exciting. There are all sorts of ways in which taking a close look at a photo can help you hone your own craft. Try to keep the following points

in mind when viewing food photos:

- Where does the main light come from?
- Did the photographer use daylight or flash?
- What aperture do you think the photographer used?
- What is it you like about the composition?
- What props were used?
- What shooting angle produced the result you can see?
- Are there obvious shadows or did the photographer use a diffuser?

As you can see, other people's photos can provide plenty of ideas for your own work. There is no rule telling you to learn everything for yourself. Use outside influences to check and develop your own technique.

How to Find and Use Sources of Inspiration

New ideas can help you get over a creative dip, and they can come from just about anywhere. People, places, movements, and food itself are all sources of inspiration. I am sure you are already aware of some of the things that inspire you most. One of my favorite sources of ideas is the Internet, which is simply chock-full of wonderful food photos.

If you are short on ideas, go online and check out recipe sites like Epicurious or search for food photos on Pinterest. If you are concerned about privacy or copyright issues, you can always use a private board. Save all the photos you like for future reference. Food photo agencies like *stockfood. com* offer an inexhaustible source of excellent photos that are sure to get your creative juices flowing.

In time, you are sure to discover photographers whose style(s) you prefer. I particularly like the work of Stephen Hamilton (*stephenhamilton.com*) and Sabra Krock (*sabrakrock.com*), and Nicole Branan (*nicolebranan.com*) is a real expert when it comes to capturing natural, home-style atmospheres. Donna Hay (*donnahay.com*) is kind of the opposite of Nicole Branan and creates photos with an almost exclusively sunny, light blue look. Most food photographers shoot in portrait format, but some simply love the landscape approach—check out *www.flickr.com/photos/58739058@N07/page1* for an example. Still lifes also provide plenty of inspiration, and my absolute favorite food photographer in this genre is Paulette Tavormina (*paulettetavormina.com*). As always, what you like and whether you share my passions is all a matter of taste.

Aside from pure food photography sites, there are countless food blogs on the web that are the online vehicle of choice for passionate food photographers. For example, *greenkitchen-stories.com* and *latartinegourmande.com* both offer culinary and visual feasts. Bloglovin (*bloglovin.com*) is a platform where you can receive updates from all your favorite blogs in one place. A quick search for "food and drink" turns up endless links for you to follow. Magazines, calendars, and advertisements are great sources too.

Another great way to keep the ideas coming is to set up a mood board with all of the clippings and cuttings you have found on your way around the world and the web. If you don't have a pin board, you can always glue the photos that inspire you to a large sheet of paper or poster board that you can stick on a wall and expand on every time you find something new that you like.

Brainstorming

If you simply don't know what to photograph next, take the first word that occurs to you in relation to food, think of or look up a recipe for it, and consider how you could set up a photo to bring it to life. Work out which types of lighting and props suit the scene you have imagined and search for similar photos on the web. Look at the photos you find and note which elements you like best in each of them. Take a careful look at the materials used, the direction of the light, and the props that might work in your own photo. These are all great ways to combat a lack of immediate ideas.

Developing Your Own Visual Style

Your own personal visual style (not your logo!) defines your photographic identity and makes it possible for people to recognize your work. Do you now who Anne Geddes is? If your answer to this question is yes, you know what I am talking about. The mention of her name probably conjures up her wonderful photos of babies rather than anything else about her life or personality. Her images are extremely creative and absolutely unmistakable—in other words, her personal style makes a big impression and makes her work immediately recognizable.

Your style isn't something you are born with—it develops over years of practice and the experience you gain turning your creative ideas into reality. Using similar processing presets, recurring compositional elements, or a certain set of materials are all ways to give your images a unique look.

The more specialized you become, the more personal your style will become. Perhaps your style is already starting to gel. If, for example, you have found you prefer to shoot with wide apertures, then you have already laid the foundations of your own personal approach. A visual language is the product of a variety of individual preferences that can only develop naturally. Show your partner or your friends a random selection of food photos with a few of your own mixed in to see which they recognize. To really succeed, you need to create great photos that are unmistakably yours.

Don't Be Afraid to Experiment

Have you ever looked at a raw ingredient and thought, "that's too beautiful to just cut up and cook"? I often feel this way when I am preparing things like figs, artichokes, and pomegranates. Instead of just throwing a bunch of ingredients into the mix, why not make an ingredient itself the subject of a photo? This is sure to give you a new perspective on food and helps diversify your portfolio.

Take a look at the photos of the romanesco broccoli below. This type of photo goes beyond still life and begins to enter fine art photography territory. Once you begin to process these images individually or add text, they turn into something that you can easily imagine putting up on your wall at home.

- For this photo, I placed a single floret of romanesco broccoli on an antique fork and, among other adjustments, added some grain to the resulting image.

- I converted the second shot to black and white and added some text that underscores the unusual look of the subject.

- The photo on the far right shows a closeup detail that I processed using a Lightroom preset (see chapter 7). The result is quite tantalizing, don't you think?

There are no limits to what you can try, so let your imagination run wild. I promise you it will be a lot of fun.

A detail shot.
ISO 100, 0.8 second, f/5.6, 100mm

A black-and-white conversion often gives a photo an enigmatic look.
ISO 100, 0.8 second, f/5.6, 100mm

In an extreme closeup, the subject takes on an abstract look all its own.
ISO 100, 0.3 second, f/2.8, 100mm

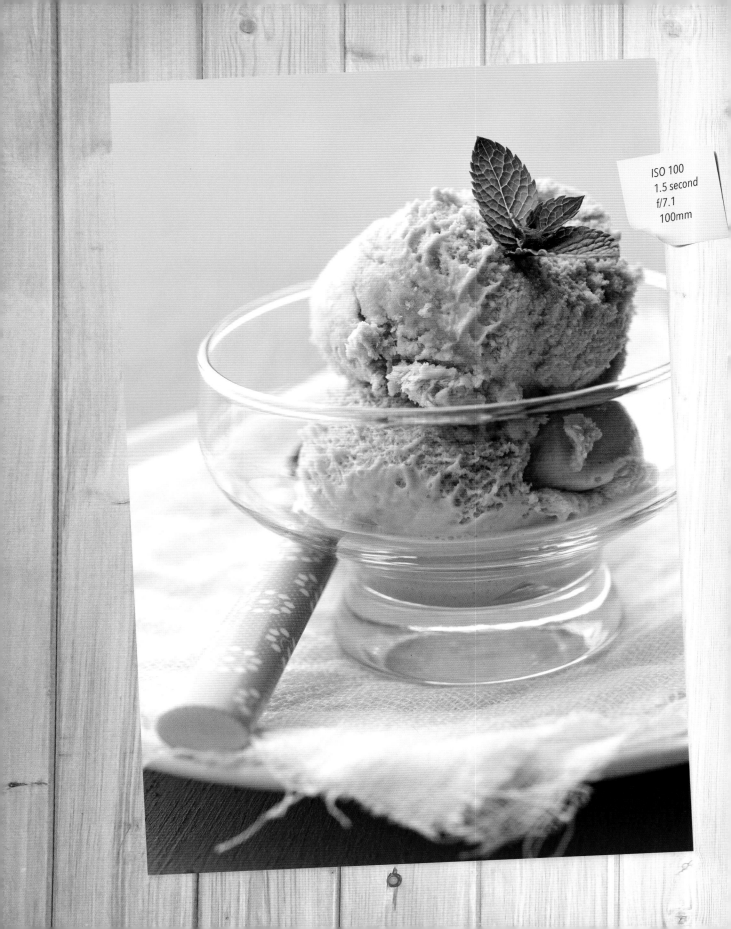

ISO 100
1.5 second
f/7.1
100mm

CHAPTER 11

Now It's Your Turn

You have now reached the end of the book and I hope you have learned plenty of new stuff to try out on your next shoot. This chapter is something of a challenge, but I hope it won't spoil your fun. I still have a great time creating food photos even though it is now my job.

The first part of the chapter recaps the work we did with camera settings and should help you to consolidate what you have already learned. Once again, part of the reward for your efforts should be eating your subject once you are done!

If you think you are ready, you can take the final challenge and see if you can pass the little test I have devised for you. This is designed to make you think and train your photographic eye.

I know I've said this several times already, but I can't emphasize enough the importance of not giving up. No one ever became an expert without practice, practice, practice. If you want to continually improve your craft, you have to acquire a lot of new skills, and the best way to do so is by learning on the job. Making mistakes is just as important as getting everything right, and when everything does finally fall into place, you can proudly present the results to the waiting world.

Still lifes are great subjects for practicing your skills.
ISO 100, 1/5 second, f/5.6, 100mm

Exercises

Because they are static and don't change shape or color, still lifes are ideal for practicing. For this exercise, set up a fruit or vegetable still life, ideally in daylight, and make sure you are relaxed and have time to go through these exercises methodically.

Ready? Close the door and start shooting!

Aperture

Capture two images of your scene using the maximum and minimum aperture settings on your lens. View the results carefully on your monitor. Can you see the difference this makes in the depth of field and the effect this has on the viewer?

ISO Value

Capture three images—one at ISO 100, one at ISO 3200, and one at the highest ISO value your camera offers. View the results at 100% magnification. Can you see differences between the shots and where noise begins to spoil the image?

Left: The narrow aperture puts everything in focus, from the near foreground to the far background.
ISO 100, 8 second, f/32, 100mm

Right: A wide aperture produces extremely shallow depth of field.
ISO 100, 1/15 second, f/2.8, 100mm

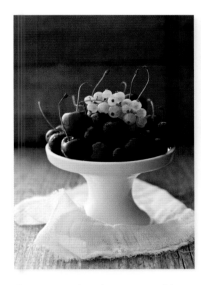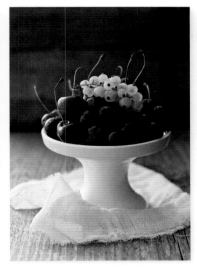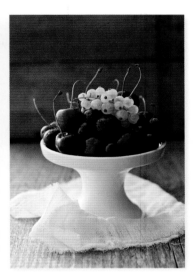

These images show three versions of the same photo processed using varying white balance settings.
ISO 100, 1/4 second, f/5.6, 100mm

White Balance

Capture three images with the white balance set to Auto, Incandescent, and Cloudy. View the images on your monitor and compare them with my sample images. Can you see how the Cloudy setting has given my sample image a warmer look? Try using different white balance settings to alter the mood of an image.

Exposure Time

Capture two handheld images of your still life scene using exposure times of 1/15 second and 1/125 second. Can you see the effects of camera shake in the image captured with a long exposure time?

M Mode

Try capturing a balanced, well-exposed photo of your scene using manual camera settings in M mode. Select the lowest possible ISO value and an aperture of f/5.6, and then manually select an appropriate exposure time. Can you use these settings to shoot effectively handheld or do you need a tripod? Try it out and see!

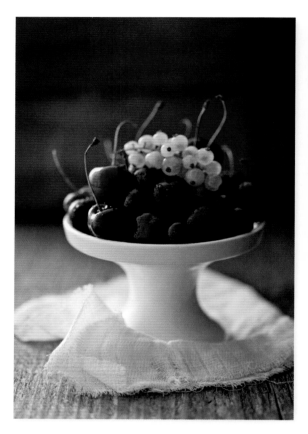

In this shot, the foremost berries are in sharp focus.
ISO 100, 1/15 second, f/2.8, 100mm

In this version, I focused on the rear of the subject.
ISO 100, 1/15 second, f/2.8, 100mm

Focus

Capture multiple photos of your scene, focusing on different parts of the subject in each shot—some closer to the foremost edge and others toward the rear. Can you see the difference this makes when you view your images on a monitor? How does altering focus affect the way you view the subject?

Quick Test

Now it is up to you to show how much you have learned.

All you have to do is look at the photos printed on the following two pages and assign the following terms to the photos that were captured using them.

- 50mm lens
- 100mm lens
- Detail shot
- Underexposure
- Shadow
- Fill reflector
- Closeup
- Overexposure
- Frontal light
- Aperture set to f/16
- Backlight
- Burned-out highlights
- Incorrect white balance
- Camera shake
- Reflections
- Incorrect focus

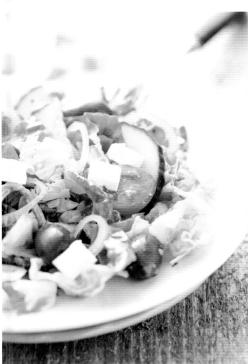

Solutions on the next page!

Solutions

 50mm lens, shadow

 Detail shot, 100mm lens, closeup, fill reflector

 Incorrect focus, shadow

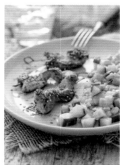 Incorrect white balance, reflections, backlight

 Frontal light, underexposure, aperture set to f/16

 Burned-out highlights, reflections, overexposure

 Camera shake

Image Sources

Index